Anette Kruszynski

Amedeo Modigliani

Portraits and Nudes

PRESTEL

MUNICH · BERLIN · LONDON · NEW YORK

Front cover: *Seated Nude*, 1916 (detail), see p. 91
Spine: *Jeanne Hébuterne – The Artist's Wife*, 1918 (detail), see p. 73
Back cover: *Reclining Nude*, 1917, see p. 98
Frontispiece: Amedeo Modigliani, 1909, photograph

The Library of Congress Cataloguing-in-Publication data is available; British Library
Cataloguing-in-Publication Data: a catalogue record for this book is available from the
British Library; Deutsche Bibliothek holds a record of this publication in the Deutsche
Nationalbibliografie; detailed bibliographical data can be found under:
http://dnb.ddb.de

© Prestel Verlag, Munich · Berlin · London · New York, 2005
(first published in hardback in 1996)

Prestel books are available worldwide. Please contact your nearest bookseller or one
of the following Prestel offices for information concerning your local distributor:

Prestel Verlag
Königinstrasse 9, 80539 Munich
Tel. +49 (89) 38 17 09-0; Fax +49 (89) 38 17 09-35

Prestel Publishing Ltd.
4 Bloomsbury Place, London WC1A 2QA
Tel. +44 (020) 7323-5004; Fax +44 (020) 7636-8004

Prestel Publishing
900 Broadway, Suite 603, New York, NY 10003
Tel. +1 (212) 995-2720; Fax +1 (212) 995-2733

www.prestel.com

Translated from the German by John Brownjohn
Copy-edited by Anne Heritage

Cover design: Matthias Hauer
Typesetting: Reinhard Amann, Aichstetten
Typefaces: Centaur and Gill
Origination: eurocrom 4, Villorba (TV), Italy
Printing: Appl, Wemding
Binding: Oldenbourg, Monheim

Printed in Germany on acid-free paper
ISBN 3-7913-3315-1

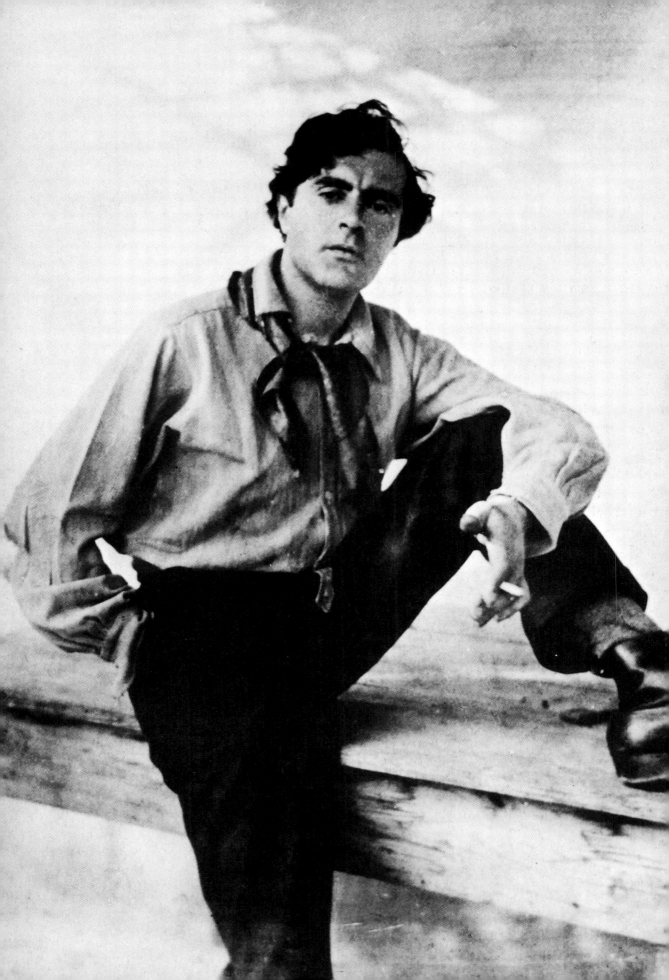

Contents

The Man and His Models

Modigliani painted human beings. This succinct statement epitomizes the entire oeuvre of the artist who has been described in such a wealth of detail: Amedeo Modigliani, nicknamed "Dedo" or "Modí," hence the pun *peintre maudit* ("cursed painter") – the lover and drinking mate, the rowdy and daredevil, the sick and lonely expatriate. Unrecorded anecdotes about the Italian in Paris abound, and the many recorded legends can still be embroidered; yet all that he painted and all that survives of his art can be reduced to that single statement: Modigliani painted human beings.

No other modern artist so steadfastly concentrated on the human form. Whatever he produced, whether portrait or nude, study or finished work, and whatever his medium, whether pencil, charcoal, or oils, it was the human being that claimed his interest. He remained loyal to human representation even during his years as a sculptor, and the few other genres he tackled are of little or no importance. Several landscapes survive from his student days and the period immediately preceding his death, but there is no evidence of either still lifes or interiors. Only in his pre-1914 music hall and circus drawings and in his late mannered portrayals of simple folk did he supply his models with meagre allusions to their social environment.

Modigliani consistently preserved the integrity of the human form in a way that was not only remarkable but, in early twentieth-century Paris, quite exceptional. Neither the Fauvists exerted any lasting influence on him. He was equally uninfluenced by collage and the radical demands of the Futurists. On the other hand, allusions to the Italian art of the Renaissance – to Titian and Giorgione – are evident in his portraits and nude paintings. He also harked back to formal portraits of eighteenth-century rulers or celebrated nudes by Francisco de Goya and Jean-Auguste-Dominique Ingres. His own inimitable style combined all these traditions with contemporary stylistic trends and

Seated Female Nude, 1917

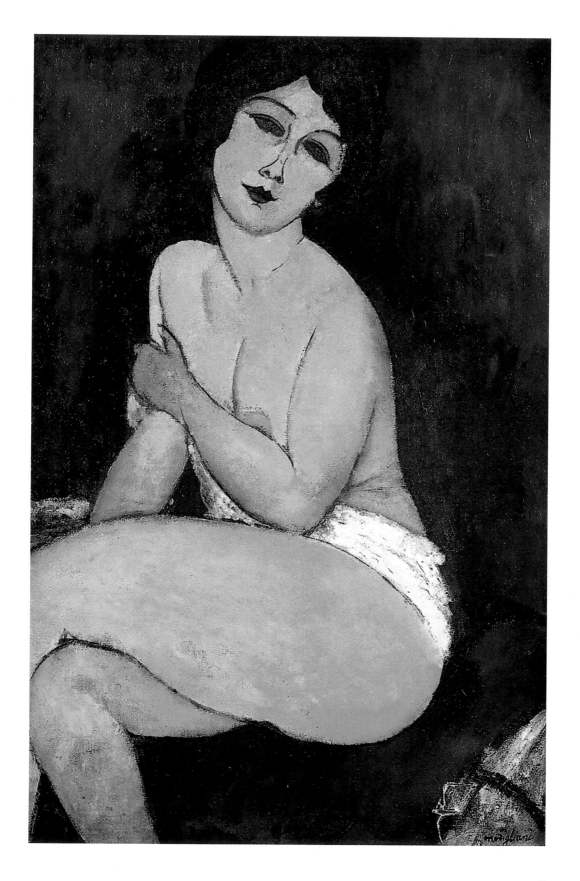

the formal principles of African and Asian art. "Modigliani" has come to signify elongated faces, blank eyes, and – of course – provocatively uninhibited nudes.

If his contemporaries are to be believed, Modigliani was an extremely gregarious individual who enjoyed sitting over a drink with friends and acquaintances. In his view, the artist was an outsider, untrammelled by the morals of middle-class society. Modigliani dazzled his friends with his knowledge of literature. He would recite Dante and Petrarch, was familiar with the works of Gabriele d'Annunzio and Oscar Wilde, and always carried Comte Lautréamont's *Les Chants de Maldoror* in his pocket, but he tended to refrain from commenting on the work of the writers in his circle. Despite his love of theater and the music hall, when it came to designing sets or costumes, he held aloof from the theatrical activities of other artists. Modigliani was a man who sought the company of others, drew strength from it, and craved it like a drug, but it was only in the seclusion of his studio that he was able to extract ideas from his brain and set them down on canvas. His alcoholic binges in bars and his nocturnal escapades on the street seem to be in stark contrast to the manic isolation he favored when working.

Modigliani's painting, whether of portraits or nudes, betrays a clarity of structure and composition quite contrary to the chaos that characterized his private life. Two very different methods of approach can be discerned here. On the one hand, the artist was addressing a problem of painterly form, for his quest for perfection can be detected in every field – in his drawings, sculptures and oils. Modigliani was interested only in human types that would lend themselves to a geometricized portrayal of perfectly balanced forms. All his nudes – without exception – belong in this category. None of them is more than a model, nor was he ever concerned here with character or personality. Even if he had a fleeting affair with the woman in front of his easel, this played no part in his depiction of her. The same applies to his portraits of anonymous sitters.

On the other hand, it can be assumed, in general, that in his portraits of particular individuals Modigliani sought to capture their character as well. Irrespective of whether a model was

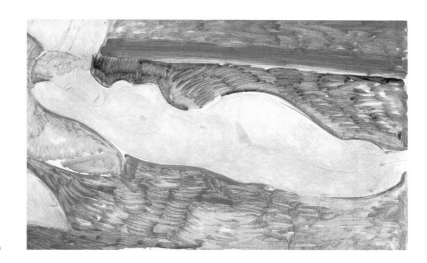

Reclining Nude, 1919

painted only once or several times, he always endeavored to convey a particular impression of his or her personality. In so doing, he also depicted his own relationship to the subject and recorded his likes or dislikes with a critical or admiring eye. These works are of male and female friends, patrons, dealers and fellow artists, lovers and intimates. The fact that this group of portraits includes no prominent figures is significant. We need not be surprised that there are no noteworthy pictures of Pablo Picasso or Guillaume Apollinaire by Modigliani, knowing as we do that he had little contact with them, and that they, for their part, had little time for him.

Beginnings in Paris

Initially, Modigliani's portraits make a uniform and monotonous impression. We feel, after examining only a few works, that we are all too familiar with his elongated faces and blank, almond-shaped eyes. His subjects' almost exclusively frontal pose and the rigidly horizontal and vertical elements never seem to vary. Only closer scrutiny reveals the above-mentioned division into model and character studies and clarifies Modigliani's stringent stylistic development.

Among his psychological portraits are those of the medical doctor Paul Alexandre. Alexandre, who saw himself as a patron and dilettante of the arts, provided rent-free studios and apartments in a house in Montmartre for artists such as Constantin Brancusi and Albert Gleizes. Modigliani not only worked there often but became so friendly with Alexandre that the artist either gave or sold him various paintings and drawings. This assured Modigliani of a certain income soon after his arrival in Paris. Although he received financial help from his family in Leghorn, their sporadic remittances were insufficient for him to live on. Alexandre's medical expertise was another factor of importance to Modigliani. The doctor kept him under constant observation, because he suffered from a chronic lung disease that called for periodic treatment and recuperation in climatically beneficial surroundings.

Modigliani produced at least five paintings and numerous drawings of his friend and patron, works whose chronology sheds light on his stylistic development during this period. These portraits should also be regarded as the nucleus of his artistic principles: frontality and austerity combined with a geometric and vertically-oriented composition. The highpoint of this series is the portrait of 1911/12, which depicts the doctor in a calm, erect pose (p. 11). The verticality of the figure, which is emphasized by the band of ornament on the right, endows it with exceptional authority and strength. Its hieratic and statuesque quality be-

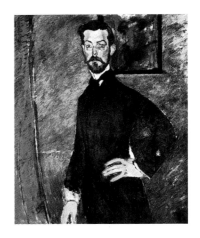

Top of page:
Paul Alexandre against a Green Background, 1909

Above:
Paul Alexandre, 1909, Charcoal

Facing page:
Paul Alexandre, 1911/12

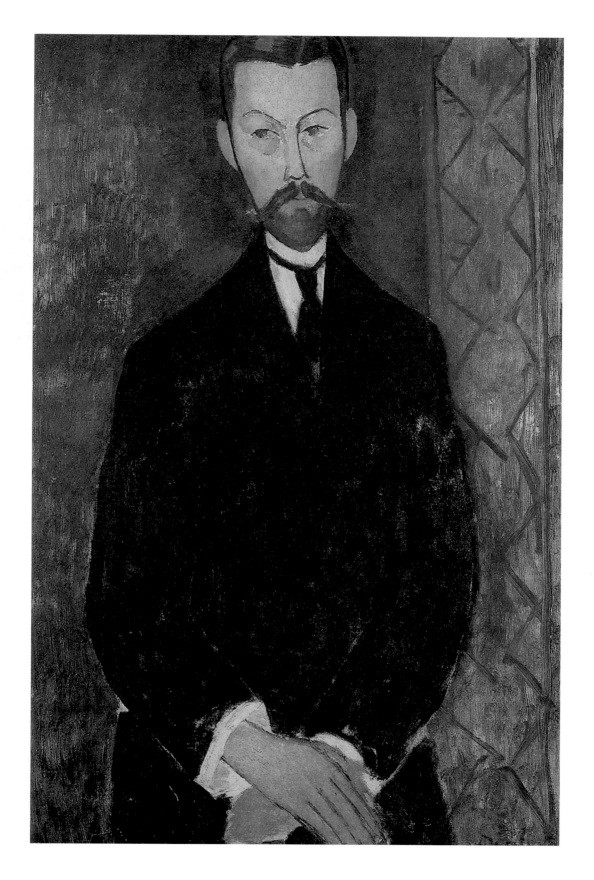

comes particularly evident in comparison with earlier portraits of Alexandre. The portrait of 1909, for example, painted against a green background looks far more lively and dynamic because of the doctor's slightly offset pose, the movement of which is echoed by the curtain and the placement of the sitter's hand on his hip (p. 10). The inclusion of a picture in the background and, more especially, the green/red and black/white color contrasts, extending into the face itself, make this earlier portrait seem almost exuberantly animated. The later portrait with the crossed hands, divested as it is of all allusions to Cézanne – whom Modigliani much admired and whose palette and style of composition he adapted – portrays a far more poised and resolute Paul Alexandre. It is the uniform coloration of brown, umber and black, relieved by a few sparse highlights, that governs this portrait.

The portrait of 1911/12 is, in turn, far removed from that of 1913. Executed towards the end of Modigliani's activities as a sculptor, it already displays his new and, for some years to come, dominant formal principle of Cubist-Futurist dissection, with its strict composition of horizontal and vertical elements (above). For all its structural clarity, this painting evokes a feeling of restlessness and indecision. It does, however, point to the masterpieces which Modigliani was yet to produce.

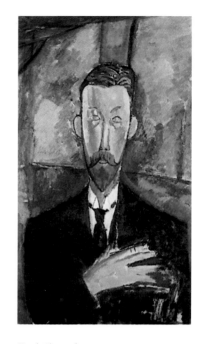

Paul Alexandre, 1913

Background and Training

Even though the portraits of Paul Alexandre already delineate the essential features of Modigliani's artistic development, the young Italian's early years in Paris were spent in a quest for his own artistic identity. He plunged into the thick of the Parisian avant-garde in 1906, hoping to experience all that he had dreamed of since the start of his artistic career. His decision to become an artist may be regarded as an almost inevitable consequence of his maternal upbringing — a childhood colored by a preoccupation with such aesthetic subjects as literature and philosophy.

The youngest of four children, Modigliani was born on 12 July 1884 and christened Amedeo Clemente (not Amadeo, as the name is often misspelled) after the males on his mother's side. His father, Flaminio Modigliani, gradually withdrew from family

Nude, c. 1896

life after a series of financial setbacks, and his mother, Eugenia Garsin, took over not only at home but also with respect to her youngest son's education. Amedeo was a frail, often sickly child who claimed his mother's full attention. Because of his poor health and his status as the last-born child, he was not expected to help support the family. This left him free to pursue his personal interests, and Eugenia Garsin reconciled her son's constant demands for attention with her own inclinations by projecting her desires onto him. The spoilt and eccentric boy was lastingly influenced by her love of classical and contemporary literature, of Dante and Petrarch as well as D'Annunzio, by her knowledge of French and the anglophilia she cultivated with like-minded friends. Whether or not he attended the Garsin household's ritual five-o'clock tea parties and listened to conversations about the much admired Oscar Wilde, he certainly profited from the English translations his mother prepared. Although he enjoyed little formal schooling and was tutored at home for a while, he was proficient in both English and French. The drawing-room discussions organized by his mother may also have brought him into contact with philosophical ideas like those of Friedrich Nietzsche. It is probable, however, that D'Annunzio's novels were his only source of information about the latter, and his knowledge of the philosopher Spinoza, whom the family believed to have been an ancestor of theirs, was probably just as sketchy.

The Modiglianis and the Garsins were Sephardic Jews whose forebears had settled in the Mediterranean area. Although not orthodox, they did not disavow their Jewish origins. In accordance with Judaic tradition, it is likely that the family did not attach much importance to the graphic arts, notably to anthropomorphic representations of God and would not have felt deprived by Leghorn's lack of a large and famous art collection. Although Amedeo's enduring and persistent interest in drawing and painting was something quite new to them, they benevolently tolerated the aesthetic aspect of this activity. Indeed, after some initial reluctance to indulge her son's passion, his mother was extremely gratified by it. Her diary eagerly records the progress he had made after only a few months at the academy: "Dedo has given up school and does nothing, day in, day out, but paint with

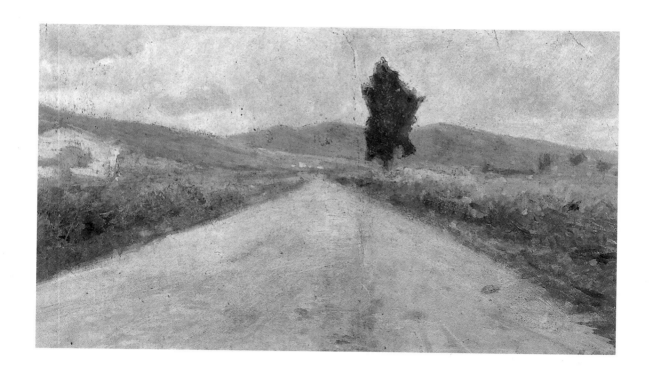

Road in Tuscany, c. 1898

an enthusiasm that astonishes and delights me. If this is not a means to success, then nothing can be done. His teacher is very pleased with him. I know nothing about it, but it seems to me that he paints not badly and draws extremely well for someone who has been studying only three or four months."[1]

From 1898 onwards, therefore, Amedeo attended Leghorn's school of art and studied under the Italian Impressionist Guglielmo Micheli, a pupil of the better-known Giovanni Fattori. His training in the classical genres of landscape, still life, nude, and portraiture took its lead from the work of these artists, who were known as the Macchiaioli. Surviving works of this period betray his teacher's influence in Modigliani's palette, technique, and handling of perspective. In *Road in Tuscany* Modigliani reduced his depiction of a landscape to an impressionistic view of a road and a tree (above). The perspective, with its low visual center, draws the beholder into the scene, and the blurred brushwork and coloring are Impressionist in style.

Even as a student, Modigliani acquired a persona approximating the *peintre maudit* role of his later years in Paris (p. 17). He

described his artistic creed in letters written to his friend and fellow artist, Oscar Ghiglia, while touring central and southern Italy in 1901/2. As an artist he wanted to "create ... a truth of my own with respect to life, beauty, and art." Borrowing the language of D'Annunzio and that of Wilde's *The Picture of Dorian Gray*, he went on: "Believe me, it is only the work of art that has reached its full term of gestation and fully matured, freed from all the hindrances of the particular incidents which have contributed to fertilize and produce it, that deserves to be expressed and translated in terms of style.... Every great work of art should be considered like any work of Nature. First of all from the viewpoint of its aesthetic reality, and then not just from its development and the mystery of its creation, but from the standpoint of what has stirred and moved its creator."[2] Modigliani saw the artist as a *superuomo* in the Nietzschean sense, that is to say, as a chosen outsider who is blessed with gifts and tormented by them at the same time:

We ... have rights that others have not, because we have different needs that place us above – one has to say it and believe it – their moral code. Your real duty is to save your dream. Your duty is never to waste yourself in sacrifice. Beauty demands some painful duties, yet they bring about the most beautiful exertions of the soul. Every obstacle we overcome marks an increase in our willpower and produces the necessary and progressive renovation of our aspiration. You must hold sacred – I say this both for you and for me – all that which may exalt and excite your intelligence. Seek to provoke and to multiply all such stimulating forces which alone can drive the intelligence to its utmost creative power. For this we must fight. Can we confine this research within the narrow limits of their morality? Assert yourself always and surpass yourself. The man who is not able to release from his energy ever new desires, almost, so to speak, like new individuals destined to overcome all that remains putrid and rotten in him, so as to assert themselves, is not a man but a bourgeois, a churl, call him what will. You are suffering, and you are right, but couldn't your suffering goad you on to further renewal and elevate your dream higher, even stronger than desire? ... get used to putting your aesthetic needs above your obligations to your fellowmen."[3]

In other words, the artist is exempt from the moral standards of middle-class society and lives solely in accordance with his own guidelines.

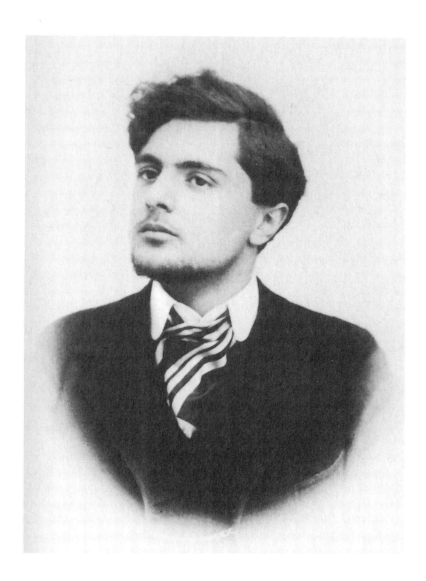

Amedeo Modigliani, c. 1902

After his Italian tour Modigliani continued his studies in Florence and Venice. In addition to attending courses there he visited museums and galleries, acquiring a detailed knowledge of Italian art that was to benefit him in his subsequent career. He saw Impressionist and Symbolist works at the Venice Biennale and became acquainted with the works of Henri de Toulouse-Lautrec through the medium of reproductions. Fascinated by his directness of expression and his predilection for the strong contour drawing of Art Nouveau, Modigliani yearned to know more of his work. He decided to leave Italy as soon as possible and set off for Paris, the hub of the modern art world.

Modigliani the Sculptor

It was Michelangelo's sculptures in Florence that kindled Modigliani's ambition to become a sculptor. While still in Italy he visited as many quarries as possible so as to gain an authentic, on-the-spot impression of the materials employed. Venice, too, fostered his dreams of a sculptor's career, but the multifarious and bewildering impressions left on him by the French capital were to delay his first work in stone for some two years.

He took his first steps in this direction by exploring the various stylistic trends that had preceded the modernist movements and producing works in which the formal aspects predominated. To perfect his drawing, he attended courses at, among other places, the private academy of the Italian artist Filippo Colarossi. In a series of works dating from 1908/9 Modigliani experimented with *fin de siècle* stylistic trends. *Head of a Young Woman*, for example, is strongly influenced by Toulouse-Lautrec's linear technique (p. 19). It was, after all, Modigliani's admiration for his work that had prompted him to go to Paris, so it is hardly surprising that several of his own works from this period look like copies. Unlike Toulouse-Lautrec, however, he completely divorces his model from her surroundings. Only a few of his drawings include backgrounds suggestive of the theater or café, circus or music hall, and in his oil paintings the focus is entirely on the portrayal of his subjects.

The Jewess also derives from his study of *fin de siècle* painting, as its startling use of color and expressive brushwork indicate (p. 21). At the same time, this dark-haired woman is reminiscent of Picasso's figures from his Blue Period. The salient features of this work are again Modigliani's concentration on the face and his pronounced contour drawing.

Second only to Toulouse-Lautrec as an enduring influence on Modigliani was Paul Cézanne. Legend has it that he always carried a reproduction of Cézanne's *Boy in a Red Waistcoat* with him. It matters little whether this story is true, because

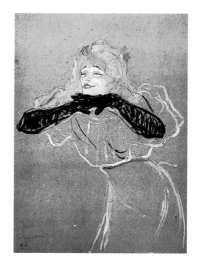

Henri de Toulouse-Lautrec,
The Singer Yvette Guilbert, 1894

Head of a Young Woman, 1908

Cézanne's influence on Modigliani, as on many other *fin de siècle* artists, was immense. Anyone who was interested in the modernist movements studied the novel visual approach pioneered by Cézanne, together with his texture, brushwork, and choice of colors. Whether Cubists or Fauves, all were in search of the new essence of art, were preoccupied with the analysis and dissection of form, or experimented with the effects of color. The autonomy of paint and canvas was a subject universally debated at this period, and Modigliani followed the other artists' example in their search for solutions to these problems. What stimulated his interest in Cézanne was the Salon d'Automne retrospective of 1907, which paid tribute to the artist a year after his death.

Modigliani's cellist portraits of 1909, not only the study but the larger work as well, are closely modelled on Cézanne's painting, as their composition and choice of colors clearly demonstrate (pp. 22, 23). Precisely because of its derivative character, however, *The Cellist* represents an example of Modigliani's purely formal portraiture. As already suggested in the discussion on the Paul Alexandre portraits, Modigliani's veneration of Cézanne is evident in his approach to composition. It was Cézanne's use of verticals and strict frontality that he adopted, not his perspective or coloristic view of objects.

Modigliani's work as a sculptor resulted in new formal impulses. True to the best Italian tradition, he wanted to work the stone like Michelangelo, who insisted that a sculpture be coaxed from the undressed block as if emerging from water.

Modigliani became acquainted with the Romanian sculptor Constantin Brancusi through Paul Alexandre in 1909, and it was Brancusi's example that he followed, both stylistically and procedurally, when working in stone. The twenty-five-odd sculptures Modigliani produced up to 1914 — here, too, he confined himself to portraying the human form — are reminiscent of Brancusi's contemporary works in their erect, stylized format and in his direct working of the stone, without modelling first in clay or plaster. Modigliani's sculptures are not portraits but female heads that mutate into slender columns. Among the exceptions are a crouching caryatid and a pillar-like figure, also female. Modigliani made hundreds of preparatory drawings for his sculptures

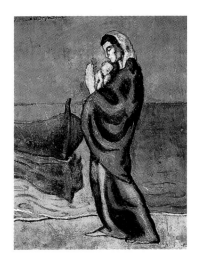

Pablo Picasso,
Mother and Child at the Sea, 1902

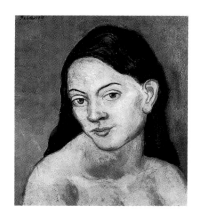

Pablo Picasso, *Woman's Head*, 1903

Facing page:
The Jewess, c. 1908, detail

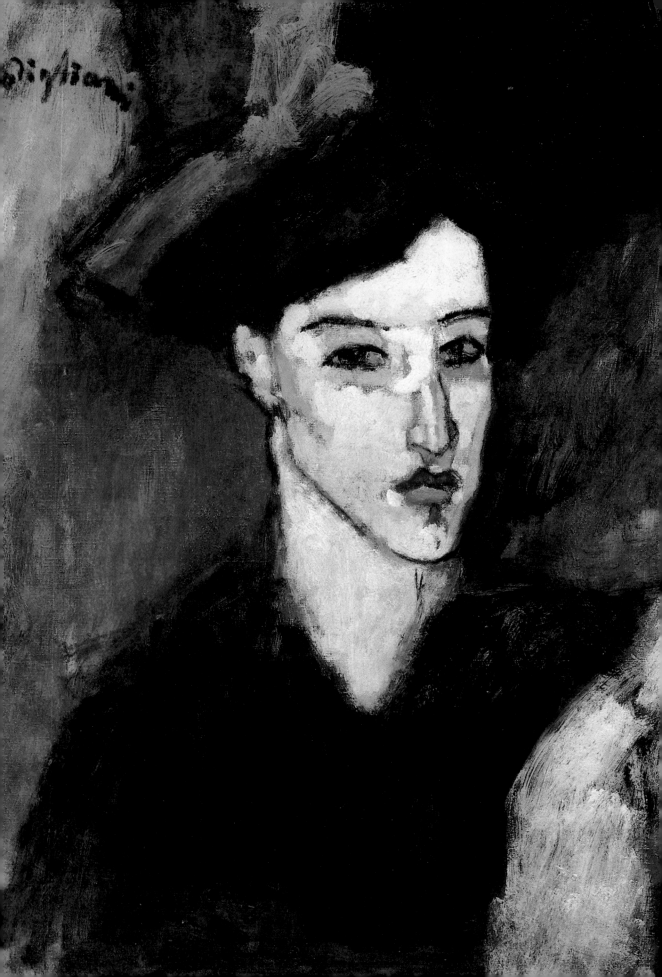

(p. 24). These laid the foundations of his development, during his subsequent period as a painter, towards clear-cut geometrical structures and a consistent pictorial architecture. Modigliani drew inspiration, not only from Brancusi's works, but also from African, Asian, and archaic Attic sculpture. His sculptured heads are almost all of the same shape. The relief-like treatment of the surface varies, but without creating any corporeal volume (p. 24).

Modigliani gave up sculpture in 1914 or thereabouts. It is often assumed that ill health compelled him to quit his dusty sculptor's studio. He may also have felt that his works in stone had no future. Not only do they display very little stylistic development, but the few exhibitions that included them — all of a rather private nature — brought him no financial success or public acclaim. Modigliani's rejection of stone as a medium may therefore have been prompted by a belief that portraiture would be more lucrative.

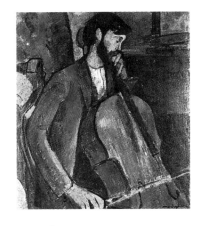

The Cellist (Study), 1909

Facing page: *The Cellist*, 1909

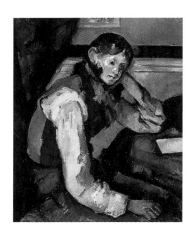

Paul Cézanne,
Boy in a Red Waistcoat, 1888 - 90

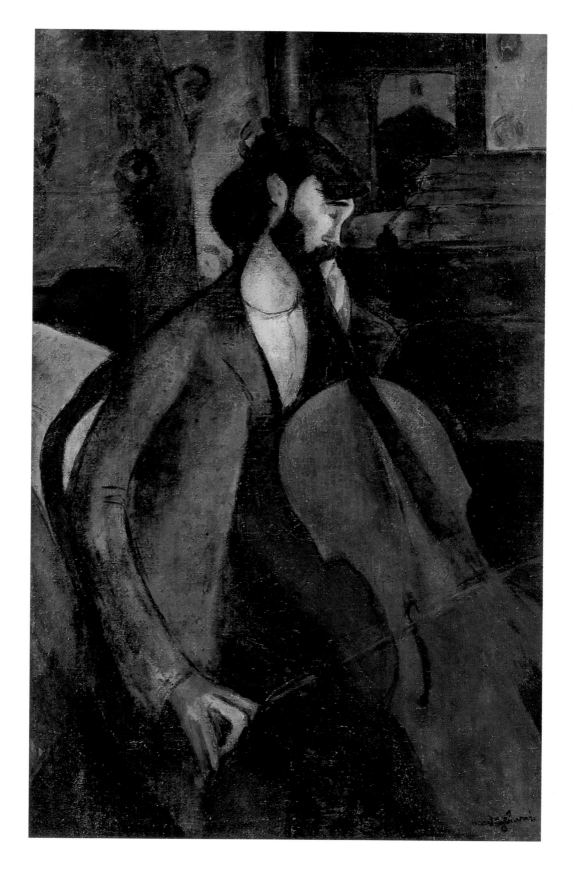

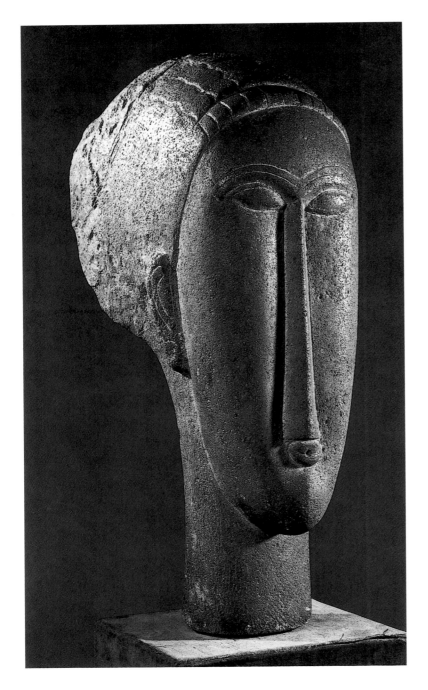

Head, 1911/12, Limestone

Woman's Head in Profile, 1910/11, Charcoal

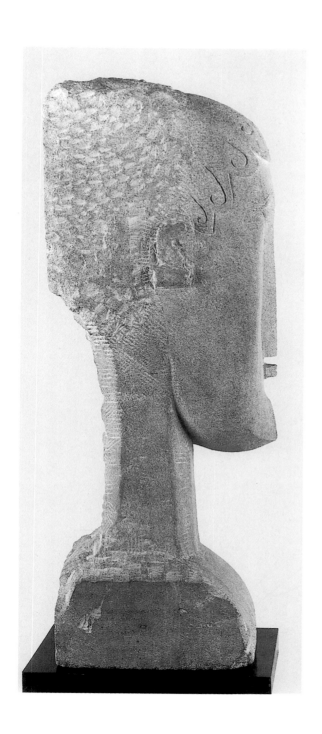

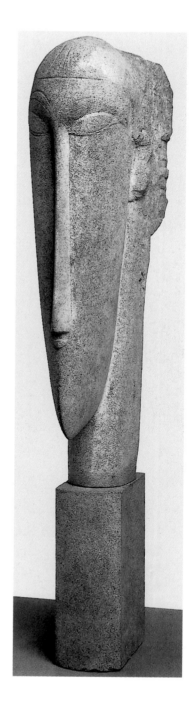

Head, c. 1913, Limestone

Head, 1911/12, Limestone

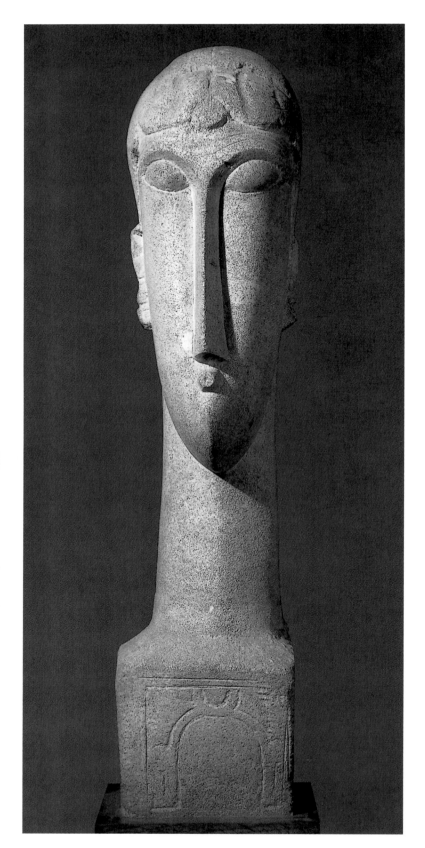

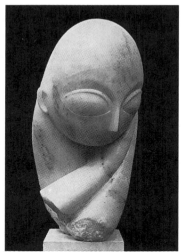

Constantin Brancusi,
Mademoiselle Pogany, 1913, Marble

Head, 1911/12, Limestone

26

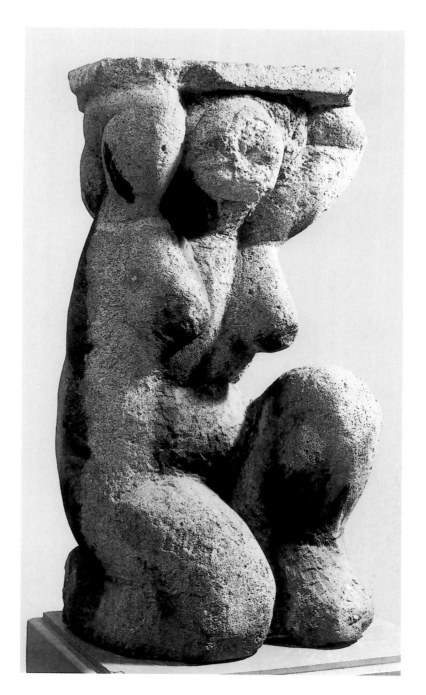

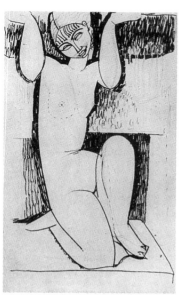

Caryatid, 1914, Limestone

Caryatid, 1910/11, Charcoal

27

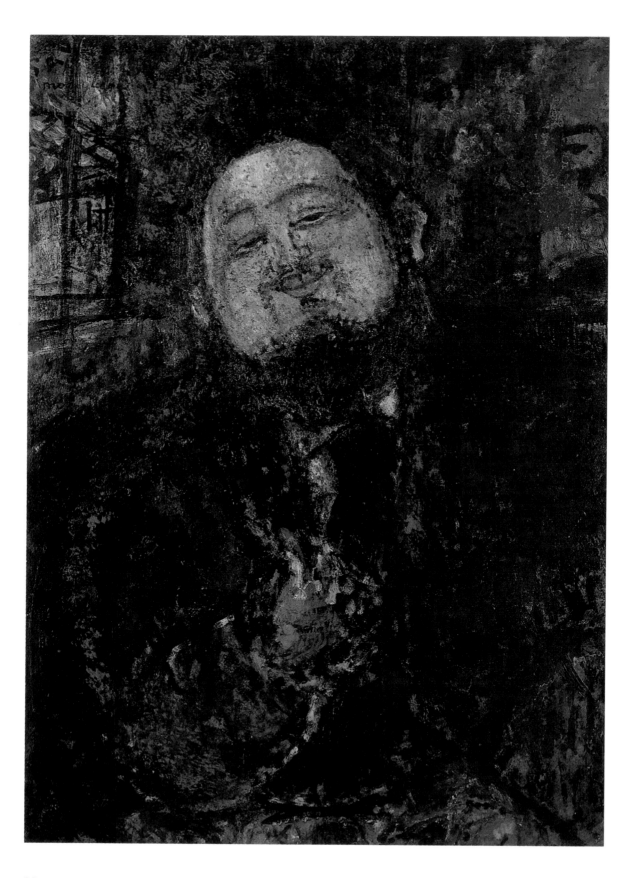

Painting Resumed

It took time for Modigliani to assimilate into painting what he had learned during his five years as a sculptor. Although he did not immediately apply strict tectonic principles to his portraits in oil, his second debut as a painter opened with a flourish. Rid of stone dust and captivated by his subject's sensuality, Modigliani began to experiment in a grand manner. The portrait of his friend and fellow artist Diego Rivera represents not only a convincing character study but an example of a brilliant and unexpectedly masterful experimentation with color (p. 28).

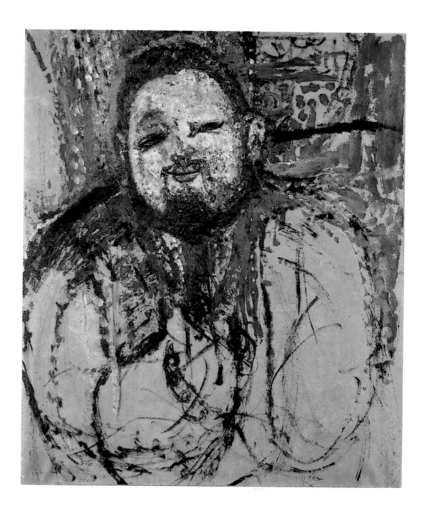

Facing page:
Diego Rivera, 1914

Diego Rivera, 1914

What is striking about Rivera's portrait and stylistically similar portrayals, such as that of Frank Burty Haviland is the brushwork: Modigliani applied paint to the ground in dabs. This was not the colorism he had admired in Cézanne's works, in which the application of complementary colors serves to unify and join surface and depth. Rather, Modigliani's technique betrays an echo of the pointillist or Impressionist painting in whose tradition he had been schooled by the Macchiaioli. But Modigliani's brushwork is also reminiscent of his work as a sculptor. It is as if the artist were treating the surface of his painting as he would limestone – as if he were carving a relief onto the ground with a hammer and chisel. Many of Modigliani's sculptures bear marks resembling these rough brushstrokes.

A legend surrounds the origin of the Rivera portraits: at a gathering with some fellow artists Modigliani suddenly seized a brush and proceeded to paint his Mexican friend while seated on the floor. Although this could account for the artist's view of Rivera from below, the final version, which was the fruit of several studies and a sketch in oils, would undoubtedly have been executed in his studio (p. 29).

It is, however, quite possible that the preliminary sketches for the finished portrait originated in this way; Modigliani was in the habit of making quick sketches with the pencil and paper he carried everywhere. He had learned to draw in this manner at the Académie Colarossi, where pupils attending the so-called "five-minute courses" practiced grasping the essence of a subject and capturing it in a few swift, salient strokes.

The Mexican is smiling contentedly with a pensive look, veiled gaze, and half-closed eyes. Whether an authentic situation or not, this is how Rivera might have looked while enjoying the company of friends: amiable, serene, and devoted to life's pleasures. Although his broad, almost circular face is framed by his chest and hair, these elements are only vaguely distinguished from the background as are the outlines of the upper part of his body, which threatens to expand beyond the picture plane. It is none the less evident from the preliminary study in oils that Modigliani did in fact outline his subject's body for structural and compositional reasons. In both versions, the study and the

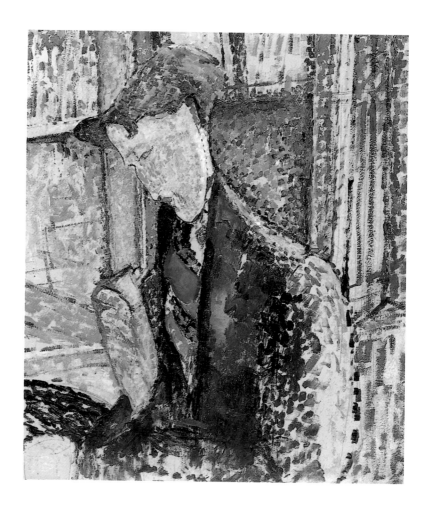

Rêverie (Frank Burty Haviland), 1914

finished work, the circular shape of the head is echoed by the bent right arm and the roughly traced pipe in Rivera's hand. In the finished painting, the ultramarine blue highlights of the jacket and the bright vermilion of the hand stand out clearly against the brown and black background. Never again did Modigliani make such dramatic use of the luminosity of unmixed paints, according them an autonomy which he may have adopted from Fauvist painters like Henri Matisse. He was far less radical than his confrères, however, and did not use intensive local color, except on a few occasions, until the last years of his life.

The portraits of Frank Burty Haviland seem at once quite different from, yet related to, those of Rivera (pp. 31, 33). Executed in one and the same technique, they give the impression

of being companion pieces to the works just discussed. Where Rivera's portrait is dominated by his sheer bulk, which appears to surge and overwhelm the canvas, the Haviland portraits are reminiscent of a drawing based on an architectural design. Once the composition was defined by its verticals, the figure's head and hand were precisely fitted into the predetermined scheme. This framework is especially dominant in the larger study. In the smaller, finished version the shapes seem softer and less constructed, and the luminous colors are once again a major feature. In this work Modigliani was concerned with characterization and concentrated on the unique aspects of his subject's personality. The jacket and necktie look overly pretentious compared with the small head and elaborate hair style. The impression is that of a man-about-town whose outward appearance promises more than his inner self can sustain.

One of the more prosperous habitués of the Montparnasse scene, Frank Burty Haviland was a would-be painter who failed to gain success or recognition. He won more esteem as an enthusiastic collector of African sculpture. Modigliani, who undoubtedly knew his collection, joined him on visits to the Cernuschi and Guimet museums and the Trocadéro, which were noted for their wealth of "primitive" African and Asian art.

Frank Burty Haviland, 1914, detail

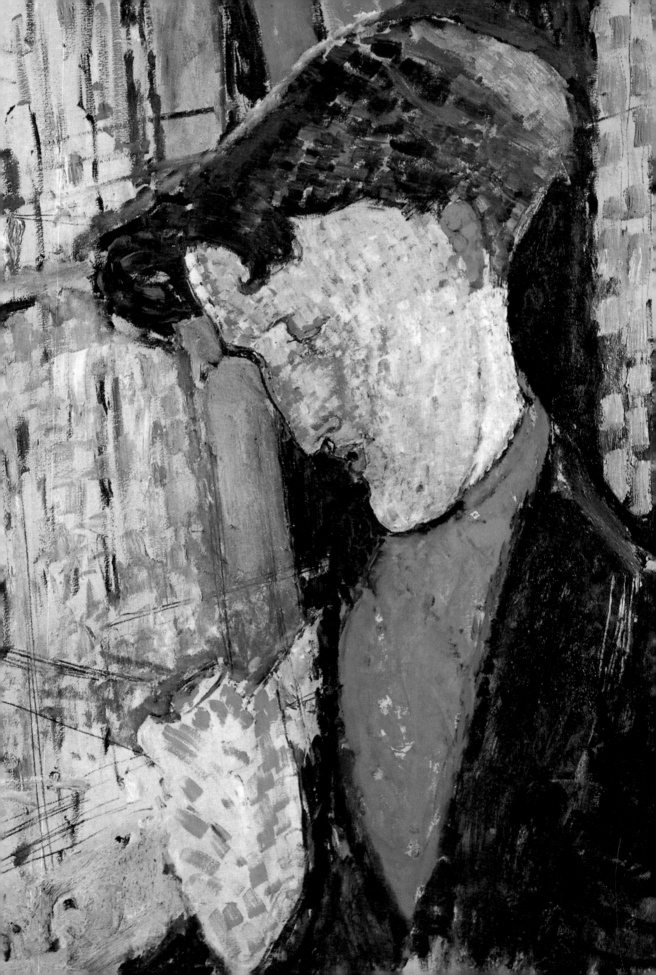

Artist and Subject

In 1915 Modigliani produced a series of small bust portraits, their common feature being the disarming directness with which they capture their subjects. Among the portraits in this series are those of Chaim Soutine, Moise Kisling, and Juan Gris (pp. 34, 35, 38), men whom Modigliani knew well and encountered almost daily in cafés and studios.[4] A sense of intimacy and familiarity can be detected in these depictions, and each work comments on

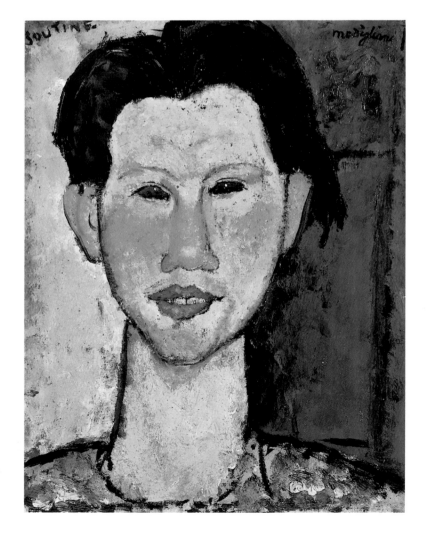

Chaim Soutine, 1915

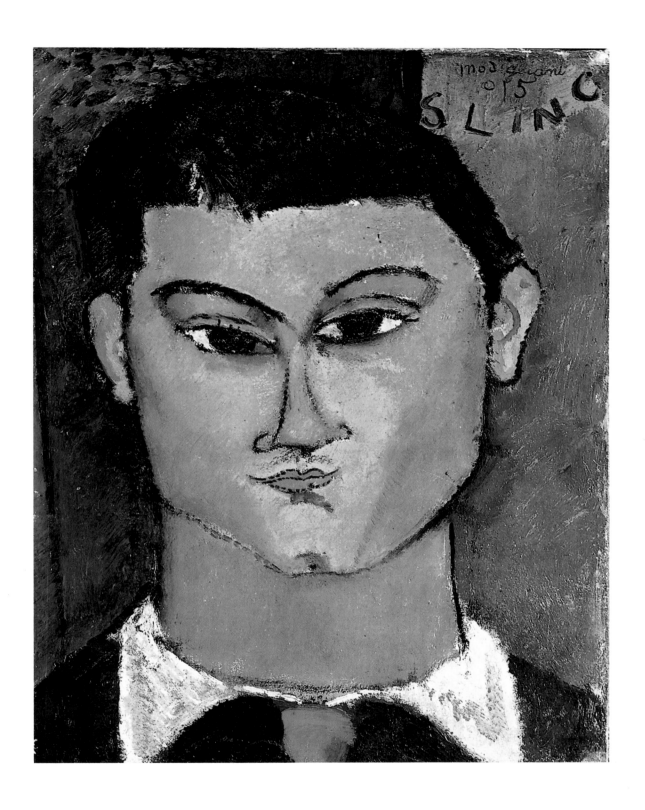

Moïse Kisling, 1915

the painter's personal relations with his subject. The fact that these portraits are restricted to head and neck brings them very close to the viewer, and there is little room for supplementary or distracting accessories. Thus both the format and the portraits themselves underscore the intimacy and immediacy with which the artist approached his subjects.

Modigliani inscribed these pictures, as he generally did with his later works, with their subjects' names. The lettering, applied in a seemingly clumsy manner, differs pointedly in style from his signature. Modigliani was following a convention that goes back to Venetian painters of the sixteenth century. Apart from identifying the subjects, the addition of names, abbreviations, and inscriptions to portraits by Giorgione or Titian often served to convey information about the mysterious fraternities to which their subjects belonged. Thus, Modigliani's use of this convention may have been a way of alluding to his intimate and personal relations with the friends depicted in his portraits. But the inscriptions are equally reminiscent of certain Cubist works. It is probable that Modigliani inserted them in his compositions in imitation of his confrères. In his case, however, their purpose was not to juxtapose and to link the inferior, everyday world with the exalted art of panel painting. Rather, Modigliani used the inscriptions to break up and vary the pictorial structure of his portraits, irrespective of their role in identifying his subjects.[5]

Of the three works mentioned above that of his fellow painter and close friend Soutine may be the earliest (p. 34). Chaim Soutine had come to Paris from Russia in 1911 and was regarded by his acquaintances as an uncouth, uncivilized fellow. Modigliani, who was very fond of him, undertook to teach him middle-class manners and improve his knowledge of literature. Their friendship blossomed, and Soutine once commented: "It was Modigliani who gave me self-confidence."[6]

With its wildly dabbed brushwork, a feature particularly discernible in parts of the shoulders, Modigliani's portrait of Soutine strongly resembles those of Rivera and Haviland, which antedate it. Completed after his Fauvist phase, this work with its use of pure, unmixed paints seems to be a reaction to Expressionism.

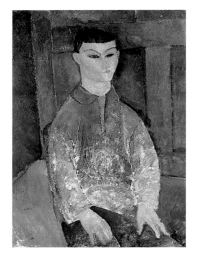

Moise Kisling, 1916

Facing page:
Moise Kisling, 1916

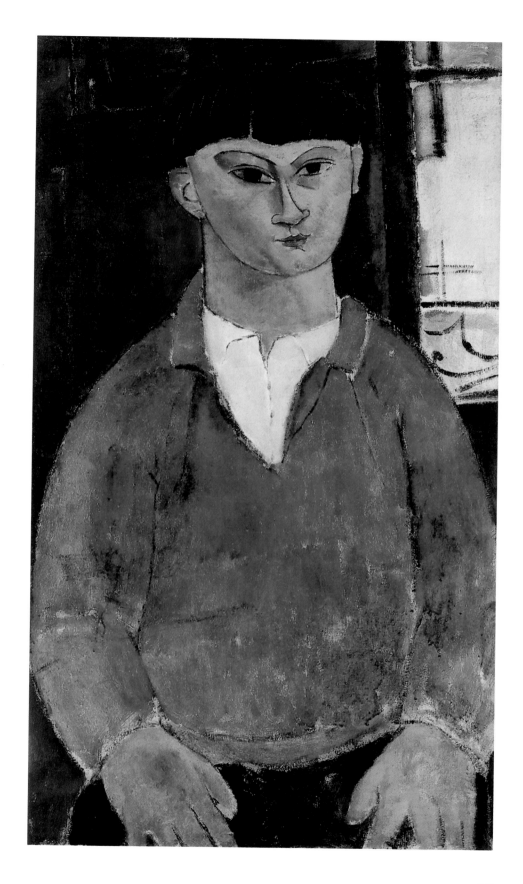

The animated style is also in keeping with the nature of the subject: Soutine in the wild, untamed state of his early days in Paris. The hair is raggedly cut and unkempt, the parted lips and bared teeth are more characteristic of a snapshot. The light shining in Soutine's eyes, which emphasize Soutine's dynamic and impulsive temperament, are unusual for Modigliani. A comparison with the three-quarter-length portrait of Soutine painted a year later demonstrates that the painter much have originally attached special importance to an element of impetuosity in depicting Soutine's character. In the later portrait his Russian

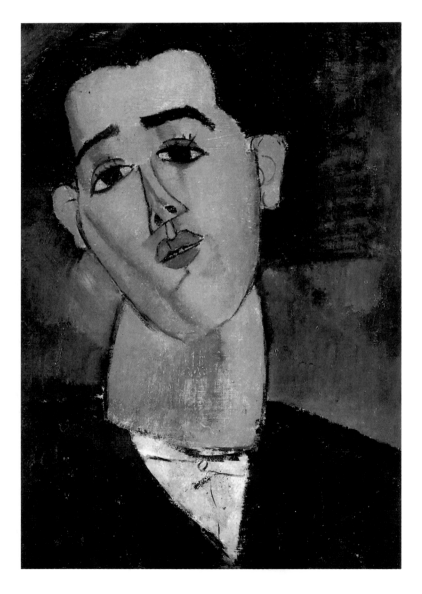

Juan Gris, c. 1915

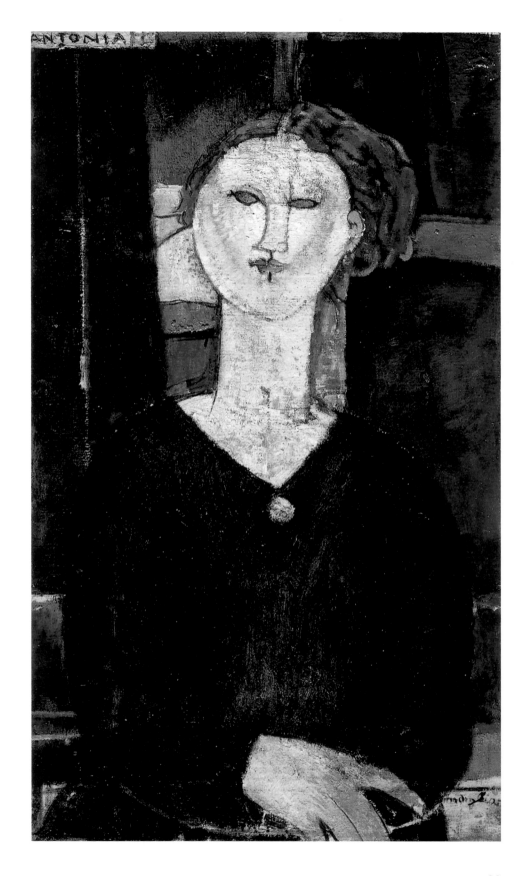

Antonia, 1915

friend radiates a feeling of calm and composure, even a hint of lethargy. Although the composition is structured by its black, contrasting outlines, the dominant forms are soft and harmonious.

By contrast, in the almost reserved-looking portrait of Moise Kisling, angular and geometrically defined lines dominate the composition (p. 35). Modigliani created a rhythmical background by dividing it vertically in terms of color, as he did in his portrait of Soutine. The brushwork, however, is far smoother and the paint applied in the manner of a glaze. His portrayal of the Polish painter, who was in his mid-twenties, is almost that of a child. What with his neatly knotted tie, smooth skin, close-set eyes, and, above all, his bright red Cupid's bow of a mouth, Kisling could be taken for an angelic little choirboy.

A similar impression is conveyed by Modigliani's later portraits of Kisling (pp. 36, 37). Two three-quarter-length portraits depict the Pole seated on a chair or stool in the same ungainly attitude, evoking the image of a plump child rather than that of a grown man.[7]

Modigliani's portrayal of Juan Gris (p. 38) stands in complete contrast to that of the pleasant but rather unsophisticated Kisling. The relatively large image – the whole portrait is in fact somewhat larger than the paintings discussed so far – with the head tilted backwards is viewed from below. The angular, dark-eyed face outlined in black gives Gris a mysterious and unapproachable air; he seems aloof and haughty. This impression is accentuated by the dark – green and black – background, hair, and jacket.

In the same year as he produced the head-and-shouler portraits of Soutine, Kisling, and Gris, Modigliani experimented with half-length portraits that exploited his experience as a sculptor. The portrait *Antonia* of 1915 is strongly reminiscent of his long-necked sculptures surmounted by stylized heads (p. 39). Despite her name, *Antonia* must be classified as a model study, not a character study, given that Modigliani's interest centered on the formal problems of composition. The portrait depicts a friendly, affable woman, but the treatment remains impersonal. Modigliani sought to relieve the structural rigor deriving from his cus-

Head, 1915, detail

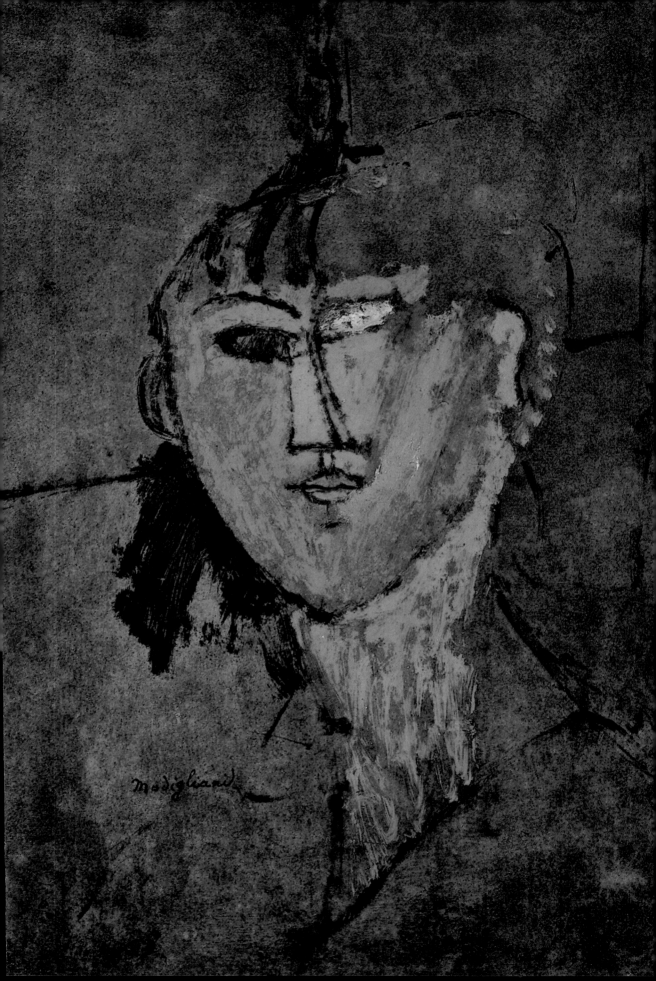

tomary frontality by giving the figure a slight diagonal tilt, a principle used by Cézanne in his portraits with a dynamic effect. The uniqueness of this work lies in its gradated use of black paint, which effectively brings out the pale and luminous flesh of the face.

Few of Modigliani's works display such an elaborate inter-play of colors, but the *Head* of 1915 must be accounted a special experiment in this field and a convincing composition made up of complementary colors (p. 41). In order to separate light from shade and thereby create an impression of volume, the artist con-trasted the black of the outlines and the red of the complexion in front of a system of co-ordinates on a green ground. Instead of depicting the hair, Modigliani contented himself with an irregu-lar edge above the eyebrows.

Modigliani attached more importance to formal structure and the composition of planes, large and small, in his *Bride and Groom* portrait of 1915 (p. 43). Its various fields of color are remi-niscent of a Cubist puzzle. The artist's signature seems so domi-nant that one is tempted to identify the male figure with Modig-liani himself. If so, its year of origin would suggest that the woman was Beatrice Hastings, his then mistress. However, the man's physiognomy and silver-gray moustache preclude such conjectures. Any attempt to credit the artist with wedding plans or a wish to get married is erroneous. On the contrary, this seems to be a variation on the theme of the ill-matched couple – the old man and the (much too) young woman – an example of Modig-liani's frequent recourse to traditional themes.

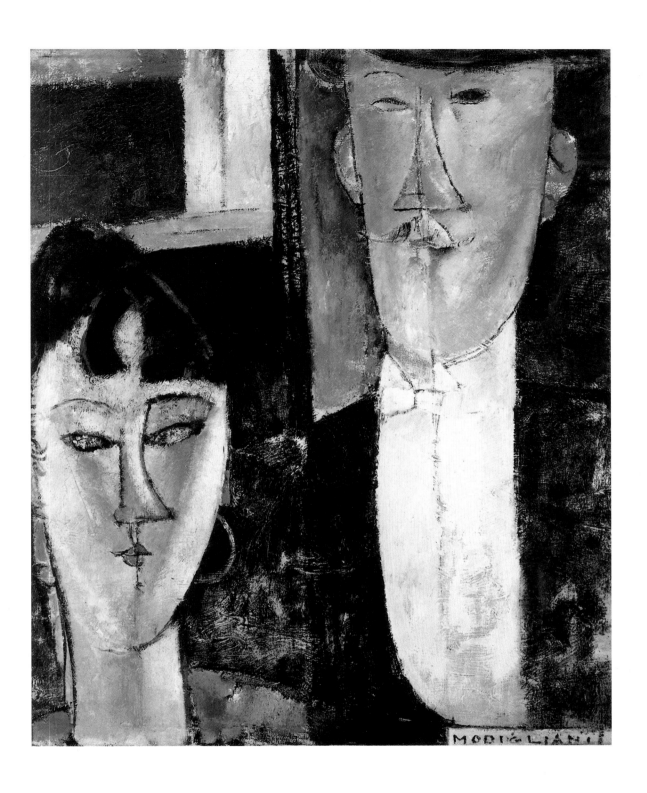

Bride and Groom, 1915

Characters from a Distance

Another painting dating from 1915 is the portrait *Henri Laurens* (p. 44). Roughly the same age as Modigliani, Laurens was a practising sculptor and one of the artists who engaged in almost daily discussions about their artistic activities. In keeping with his Cubist phase, Modigliani depicted his friend using a combination of formal principles that he had developed himself. The result is a portrait in which forces not only operate against each other but are also forever striving to achieve a compromise. Modigliani adapted his palette to his subject by selecting colors — the restrained greenish blue and, more especially, the shades of gray and brown — that call to mind the blocks of stone with which Laurens worked.

In the portrait *Juan Gris* Modigliani was still depicting eyes with pupils and irises (p. 38), but in his painting of Henri Laurens he moved away from a uniform representation of the eyes, blinding one of them by blacking it out. This device made his subject appear to be contemplating an inner being and perceiving truths denied to those who can see. The use of blank eyes, which are particularly important to characterization, was not Modigliani's own invention. The Cubists, of whom Laurens was one, employed a comparable procedure in their analysis and deconstruction of the human form. Giorgio de Chirico, too, made use of blank eye sockets. Being an integral part of the formal structure of the composition, they do not seem as foreign in the Cubists' works. In Modigliani's case, however, the blank eyes attain prominence because his portraits are, for the most part, organically intact. They have thus become one of the hallmarks of his painting.

It is uncertain whether Modigliani failed to complete the Laurens portrait or deliberately lent it a *non finito* appearance as a stylistic aid. In any case, its present state enables us to trace the artist's mode of procedure. Having delineated the composition with dark brushstrokes, Modigliani proceeded to fill the result-

Henri Laurens, 1915

ing expanses with color. He often left the contour lines visible, thereby rendering a predominantly two-dimensional impression.

Henri Laurens is one of the few examples of Modigliani's work to display an unusual wealth of ambient detail (p. 44). The sculptor is shown seated at a small café table on which rest his pipe and tobacco pouch. The background is only vaguely suggested by vertical slabs of color.

The painter, writer, and film director Jean Cocteau is also depicted in a knee-length portrait (p. 47). His pose and physiognomy convey Modigliani's lack of involvement with the snobbish-looking Cocteau. He emphasized his subject's air of pretention by reinforcing the verticals of the erect figure in its close-fitting suit with the back of the chair. The other verticals that call attention to both the background and the figure underscore its affectation and gauntness.

The portraits we have discussed so far are of men who either assisted Modigliani like Paul Alexandre, were good friends like Rivera, Soutine and Kisling, or belonged to his wider circle of acquaintances like Haviland, Gris, Laurens, and Cocteau. None of them asked to be painted, much less paid for the privilege. Modigliani's financial situation was as bad as ever, nor was he by any means the economical sort. His paintings fetched very little money, even on the rare occasions when he found a buyer. The artist often made unsolicited sketches of people in cafés and tried to barter them for the price of a lunch or a few glasses of wine.

Modigliani pinned his hopes of better times on Paul Guillaume, whom he met in 1915. Guillaume was an art dealer specializing in African sculpture, who also took an interest in the work of artists such as Matisse, Picasso, and André Derain. Quickly perceiving that there was money to be made with the Italian artist's work if only he could tailor it to the market a little more, Guillaume proceeded to sponsor Modigliani and rented a studio for him. The two portraits of the art dealer, which Modigliani painted in token of his gratitude, are undisputed highlights of his oeuvre. The first of them originated in 1915 and bears the inscription NOVO PILOTA (p. 48). Modigliani, who saw Guillaume as a new guiding star in his life, depicted him as an elegant young man wearing a dark suit and hat. The figure's slightly

Man with Hat (André Derain), c. 1918, Pencil

Jean Cocteau, 1916

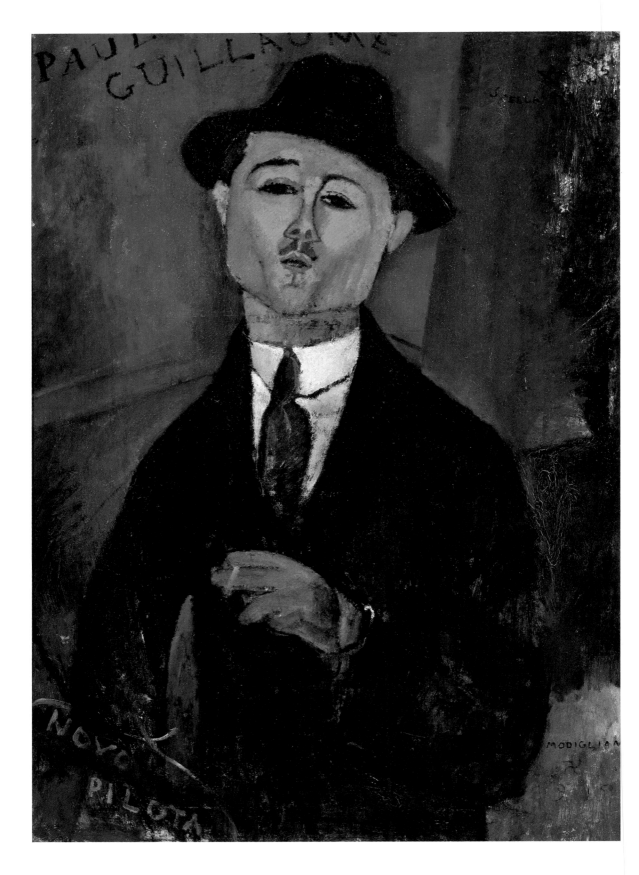

Paul Guillaume (Novo Pilota), 1915
Paul Guillaume, 1916

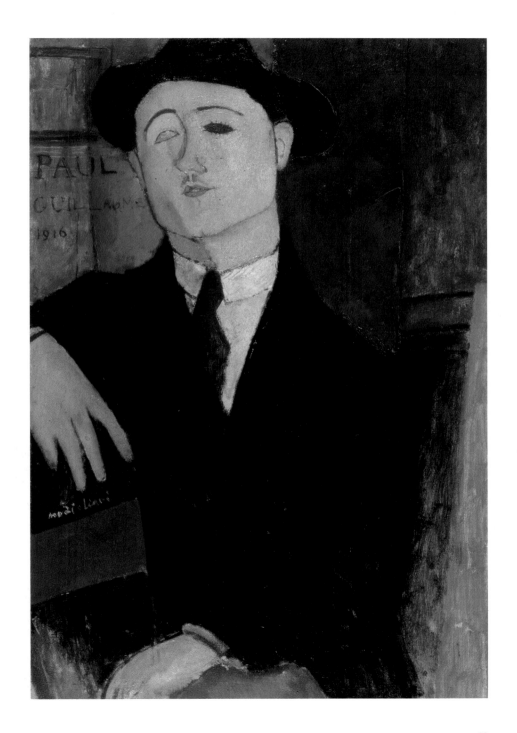

elevated position underlines its air of sophisticated nonchalance, which is conveyed in particular by the angle of the head and the cigarette in the gloved hand. The portrait's crowning feature is the contrived effect of the moustache.

The portrait *Paul Guillaume* painted a year later is far more detached and communicates an unmistakably negative message (p. 49). Here, Modigliani completely abandoned the sympathetic and friendly irony that characterized the earlier work. He also dispensed with the programmatic inscription of the first portrait, confining himself to the identification of his subject. No longer encased in a sweeping, ornamental semicircle, his name is only partly visible in a straight line on the figure's left. The seated pose and propped elbow, but most of all the elevated position of the erect head, suggest a personality governed by arrogance and aloof condescension. We sense that the artist now sees through his business-oriented and profit-minded subject and no longer wishes to be exploited for someone else's benefit.

Personal Tributes

In a portrait painted in 1916 Max Jacob is as smartly turned out as Paul Guillaume (p. 52). Far from creating a cheeky and arrogant impression, however, the suit and top hat emphasize the subject's dignity. That this portrait is Modigliani's special tribute to a close friend can be inferred from a drawing which the artist made of the finished portrait in oils, presumably to compensate for his having sold it, and which bears a dedication indicative of their close relationship.

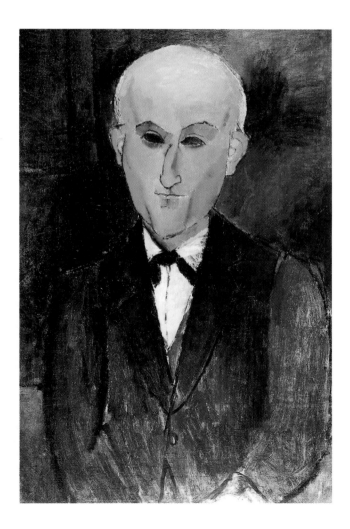

Max Jacob, 1916

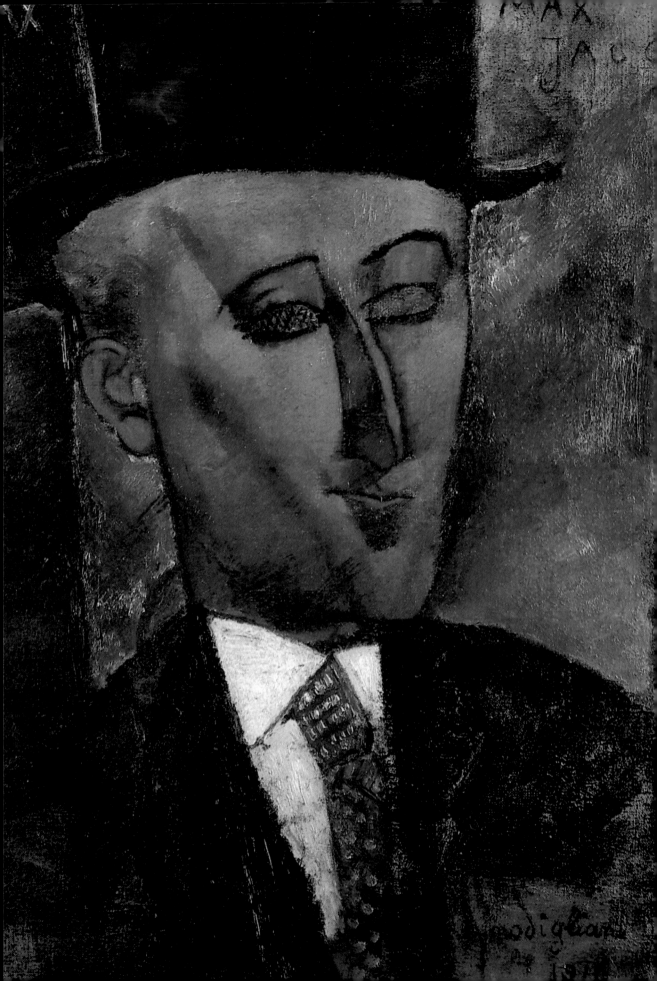

Modigliani portrayed the diminutive poet, critic and artist as the *grand seigneur* of Jacob's own self-image. The larger-than-life-size, bust portrait is executed in warm brown and red tones reminiscent of earth and glowing embers. It also conveys the intelligence and sensitivity of a man tormented by self-doubt, and is certainly one of Modigliani's most penetrating portrayals of an individual. Set against a dark, geometrically structured background, the prominent ear and small, insignificant mouth lay stress on the receptive disposition of a born listener who expressed himself less in speech than in prose and verse. The face, which looks almost carved, is reminiscent of an African mask and the formal principles of the Cubists. The offset three-quarter view and its compositional and chromatic concentration on the face heighten the elegance and extreme intensity with which Jacob casts his spell over the viewer. This becomes even more apparent when we compare this portrait with others of Max Jacob, for instance the one in Cincinnati Art Museum, which was also painted in 1916 (p. 51). Its slightly inclined pose and rather sentimental expression lend the sitter a small and inconspicuous appearance.

Modigliani's output in and around 1916 represents an undoubted high-water mark in his oeuvre. After his schoolboyish beginnings and a lengthy excursion into the realm of sculpture, he now had a firm grasp of his artistic repertoire. He had successfully applied, to his own works, the fruits of his sculptural experiments, his knowledge of other cultures and his confrères' stylistic achievements; he had learned how to orchestrate the effect of colors and use them to his own advantage. Such was the self-assurance with which he now concentrated on portraying the characters of his acquaintances, friends and lovers, as we saw in the Jacob portrait.

Modigliani painted a series of character studies about one and the same person, namely, his long-time friend and mistress Beatrice Hastings. The couple met in 1914/15, and the numerous portraits that originated during their liaison record the ups and downs of their relationship.

A self-confidant, professional woman who had come to Paris from South Africa by way of England, Beatrice Hastings

Max Jacob, 1916

Facing page:
Max Jacob, 1916, detail

edited periodicals and wrote poetry. Her relations with Modigliani were marked by fervent passion and stormy quarrels. Judging by his portraits of her, Modigliani was both intensely fascinated and profoundly disturbed by Beatrice. The widely differing portrayals of her might tempt one to assume that they depict a series of female types, yet the artist's main concern was to lend expression to his own attitude towards his mistress. On the one hand, he strove to produce stylized, seemingly dispassionate and objective portrayals of the woman who unnerved him; on the other, he flattered her with deep affection and pictorial protestations of love. Even his most merciless character study of Beatrice, which depicts her in an aloof and arrogant manner, is primarily an attempt to surmount his own problems (p. 55).

The *Madam Pompadour* portrait of 1915, which dates from the beginning of their affair, combines the various roles that Beatrice played for Modigliani (p. 59). The very title of the work conveys the two different aspects of her character. "Madam" alludes to her British origins, "Pompadour" to the celebrated mistress of Louis XIV. The broad-brimmed, befeathered hat also seems to derive from the seventeenth century, but Modigliani was not concerned with social or historical classification; he was, in his own way, relating the exceptional position of power once enjoyed by Madame Pompadour to his own situation.

Other examples show Beatrice Hastings in quite different roles. Also dating from 1915 is a portrait that undoubtedly stems from the happier days of their relationship (p. 56). The beloved friend in her simple smock blouse looks graceful and charming and, at the same time, maternally warm-hearted. Indeed, Modigliani expressly entitled a drawing of this period "beata matrex" (= matrix), or happy mother.[8] This was no doubt wishful thinking on his part, however, because Beatrice Hastings could not have been less suited to that role. The portrait depicting her as a little girl in a blue checked chemise must likewise have sprung from the artist's imagination (p. 57).

It is far more likely that the portraits conveying Beatrice's true nature are those that show her as a poised, elegant, rather arrogant woman. In one of these, which belongs to the Barnes Foundation, Modigliani heightens the impact of the subject,

Portrait of Beatrice Hastings, 1916, Pencil

Facing page:
Beatrice Hastings, 1916

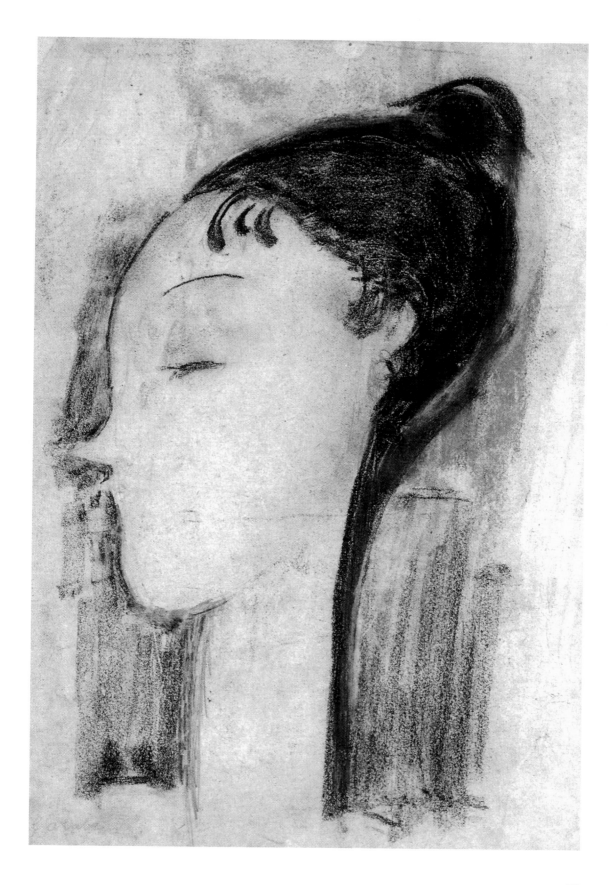

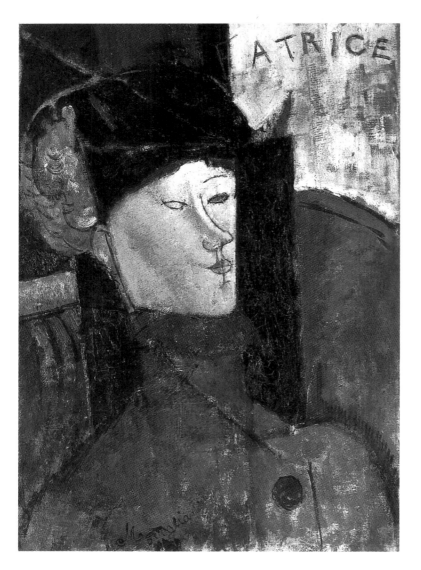

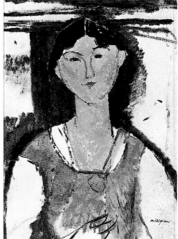

Above: *Beatrice Hastings*, 1916

Right: *Beatrice Hastings* (Study), 1915

Facing page: *Beatrice Hastings*, 1916

56

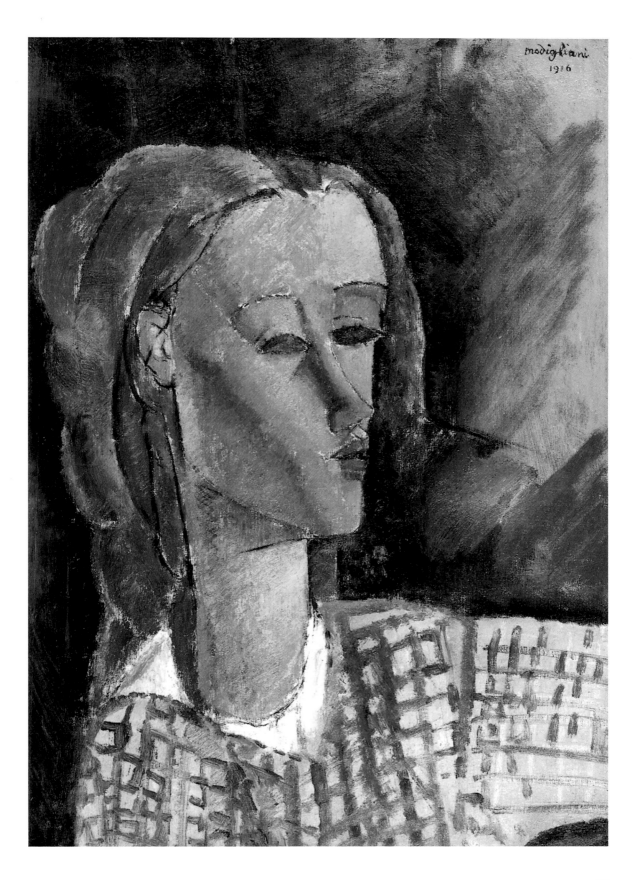

who is looking sideways out of the picture, by means of a dark, rectangular background (p. 56). Beatrice is inclined backwards, and the high-buttoned coat creates the impression of a rigid, yet vigorous, personality.

Despite all their efforts, the two sparring partners proved incompatible. Beatrice was unable and unwilling to give her mercurial lover the stability — not to mention the financial security — he needed. As for Modigliani, who had undoubtedly derived great benefit from their intellectual duels, he nearly foundered under the weight of her strong personality. His diverse portraits of her document more vividly than those he painted of anyone else, including Jeanne Hébuterne, the way in which he coped with their relationship.

Madam Pompadour, 1915, detail

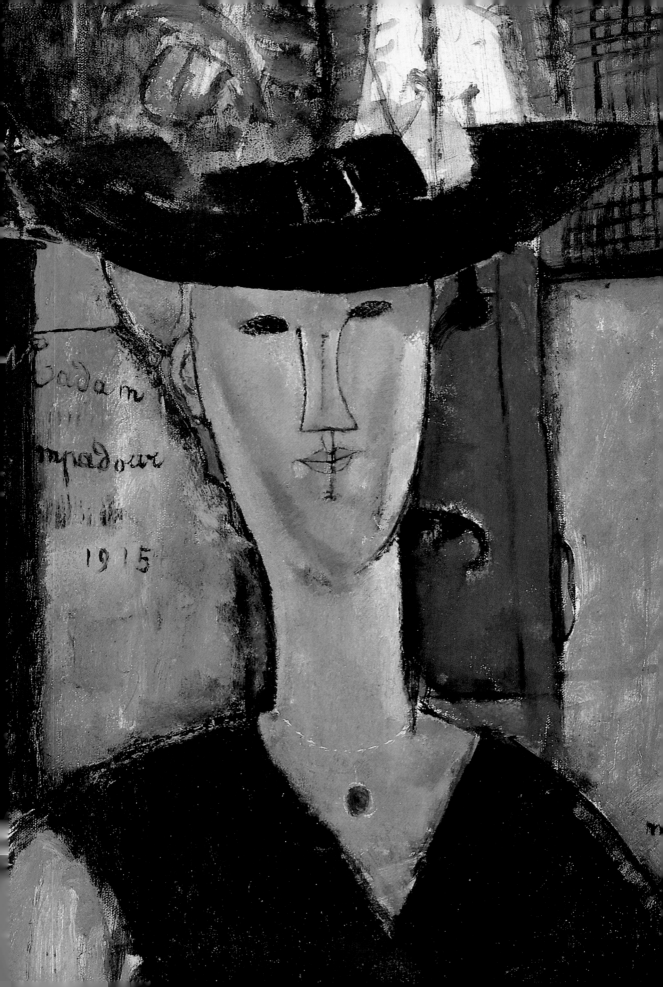

The Decorative Tendency

Although radical changes in Modigliani's work coincided with developments on the world stage, the relationship between them was not directly causal or even compelling. Thus, although he finally gave up sculpture in 1914, on the outbreak of the First World War, his decision was not a response to the military situation. It was probably the severing of his links with Paul Alexandre, occasioned by the war though this was, that led him to abandon the sculptor's medium.

Modigliani's work began to manifest a further stylistic change in 1917/18. At a time when the existing social and political structures had proved unsustainable and social upheavals – revolutions, even – were imminent, his portraits counteracted this trend, as it were, by signalling a fulfillment of the universal desire for harmony. It would, however, be wrong to construe Modigliani as a direct and deliberate precursor of movements such as verism or Ingrism, which seemed to satisfy a comparable striving for harmony.

In 1917, at all events, he began to modify his style of painting. Abandoning the hard, geometrical type of composition that had hitherto characterized his portraits, he also refrained from his often pastose application of paint with its dynamic and powerful effect. From now on his brush travelled across the canvas with uniform intensity, applying paint that had been greatly thinned. This heralded the period when Modigliani received occasional portrait commissions and found, in Leopold Zborowski, a dealer who attended to his protégé's mental and physical welfare.

Modigliani's change of style was accompanied by the development of a new focal point in his portraits. Psychologically informed character studies became ever rarer; instead, he produced dazzling formal portraits that betrayed a strong Baroque influence. One outstanding example is the double portrait *Jacques and Bertha Lipchitz*, which dates from 1917 (p. 61). The Lithuanian sculptor commissioned this work, which was based on a photo-

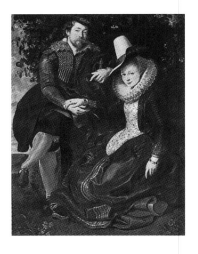

Peter Paul Rubens,
Honeysuckle Lute, c. 1610

Facing page:
Jacques and Bertha Lipchitz, 1917

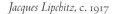

Jacques Lipchitz, c. 1917

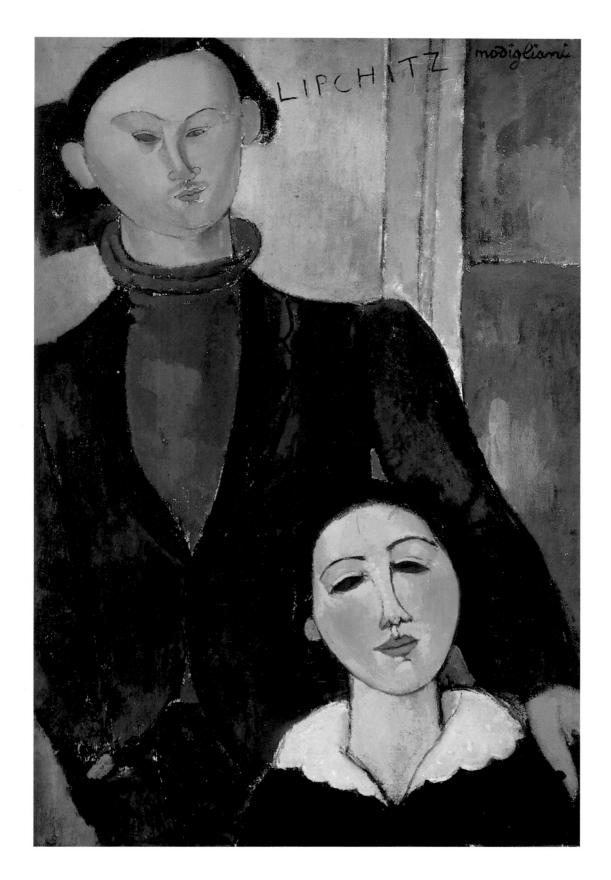

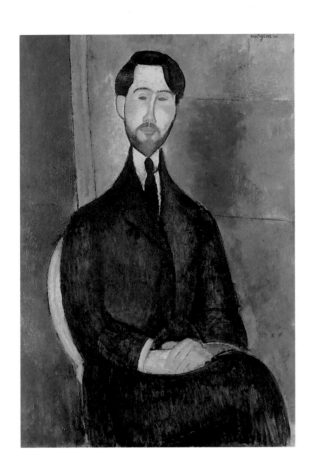

Leopold Zborowski, 1919

Leopold Zborowski, 1916

Facing page: *Leopold Zborowski*, 1916/17

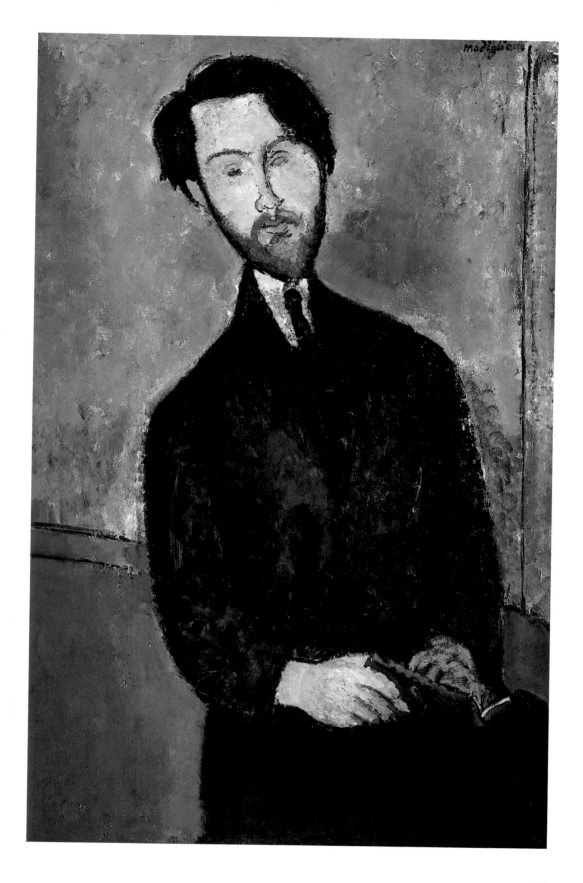

graph of the bride and bridegroom, on the occasion of his
marriage.

No group portraits by Modigliani have ever been found, and
he seldom undertook a double portrait. One rare example is the
portrait *Bride and Groom*, which originated in 1915 and is still
composed entirely in an analytical, Cubist style (p. 43). The Lip-
chitz double portrait, by contrast, is composed of soft, fluid
forms. The bridegroom is shown standing behind his seated bride
with one hand on her shoulder. The numerous drawings that pre-
ceded this portrait enable one to trace Modigliani's gradual, ten-
tative path to his final composition. The first sketches, which
confine themselves to a single person, clearly display elements of
previous compositions in which figures were fitted into a system
of co-ordinates. Then oscillating lines and flowing shapes gain
the upper hand but are counterbalanced by the vertical and hori-
zontal structural elements in the background. Lipchitz and his
wife are depicted as agreeable individuals but from an unwontedly
dispassionate viewpoint. This became an especially characteristic
feature of Modigliani's portraits in the years to come.

Before turning entirely to decorative representations and
sentimental genre portraits, Modigliani concentrated both on
formal elements and on the psychological characterization of his
models. His intimate knowledge of art history – which Modi-
gliani never ceased in applying – is attested to by his use of
courtly Rococo portraits, which also satisfied his desire for
dignified elegance, as models for numerous important works.

Certain portraits of Anna and Leopold Zborowski are
notable members of this category. A native of Polish Cracow,
Zborowski had been in Paris since 1914. He liked to think of
himself as a poet, but his interest in fine art enabled him to
become more successful as a dealer. In 1916 he succeeded Paul
Guillaume as agent for Modigliani and not only became his
financially dependable partner but also assisted him in private
matters. He entered into a contractual agreement with the artist
under which he demanded a certain number of works in return
for a regular retainer. In gratitude to Zborowski and to his wife,
with whom he was also friendly, Modigliani painted several
portraits of the couple that reflect their amicable relationship.

Jean-Honoré Fragonard,
Singing, c. 1800

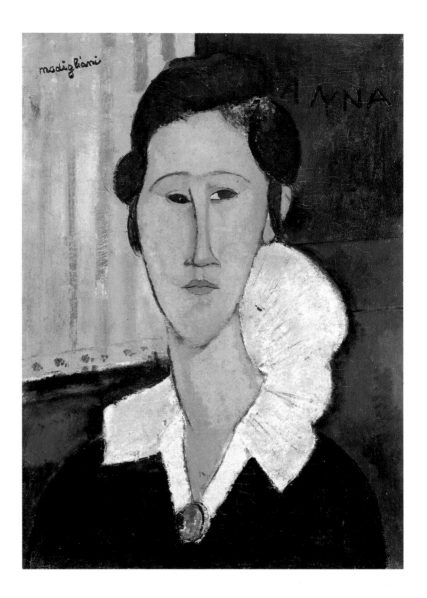

Anna Zborowska, 1917

His portraits of Leopold Zborowski range from very inti-
mate depictions of the art dealer as a friendly, warm-hearted man
to others that emphasize his consummate elegance (p. 62).
A kind of intermediate position in this process of development,
which spanned the years 1916-19, is held by a portrait showing
Zborowski with a book in his hands (p. 63). The attributive de-
tail is not solely an allusion to his literary bent. Together with the
elongated formal elements of the figure's body and head, which
are uninterrupted by any horizontals, it is above all a recourse to
comparable portraits of the eighteenth century, for instance

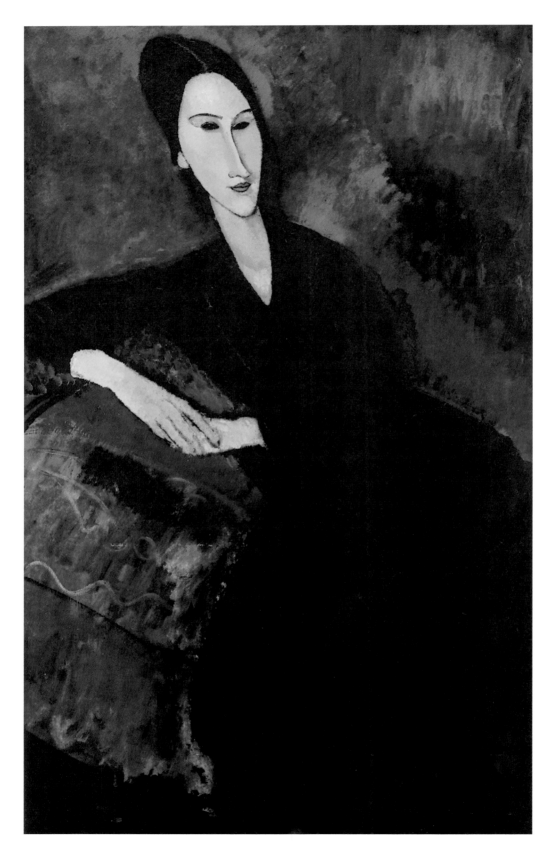

those by François Boucher or Jean-Honoré Fragonard. Here, characterization yields pride of place to Modigliani's other known talents. Zborowski looks amiable but, at the same time, clumsy and ungainly; all in all, the painting says little about the subject's character.

Comparable portraits of Anna Zborowska disclose the direction in which Modigliani's new style of composition was leading him. His depictions of the dealer's wife, whom he painted many times, were never as personal as those of her husband. Where she was concerned, the artist always preserved a respectful distance. Even in a small, intimate bust portrait she is portrayed with cool admiration (p. 65). Another portrait, which shows the Polish noblewoman reclining on a sofa, was executed wholly in the French Rococo style and can be seen as his grandiose tribute to her (p. 66). In this work Modigliani successfully undertook a daring, diagonally structured composition into which the model is inserted at an angle. Her pose is, in fact, reminiscent of court portraits of the eighteenth century. The simple, unadorned dress in black – a color which Modigliani was never again to employ with such intensity – enhances the majesty and beauty of her slender figure. The face, neck and hands are compositionally elongated, and the eyes display the almond shape characteristic of the artist's late work.

Anna Zborowska, c. 1917, Pencil

Facing page:
Anna Zborowska, 1917

Jeanne Hébuterne

Modigliani continued until the end of his career to paint portraits which, like those of the Zborowskis, incorporated attributes or ornamental accessories as an element in their composition. The finest works he produced between 1917 and 1920 are founded on masterly pictorial structure and bold, flowing lines. Begun at the end of 1919, his rather sentimental portrait of the musician Mario Varvogli also displays fluid forms within interlocking segments, effectively set off against a vertically and horizontally structured background (below). As in all

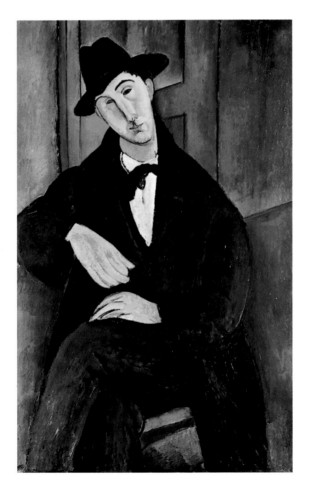

Mario Varvogli, 1919/20, Pencil

Facing page:
Jeanne Hébuterne, 1918

*Portrait of
Mario Varvogli,
1919/20*

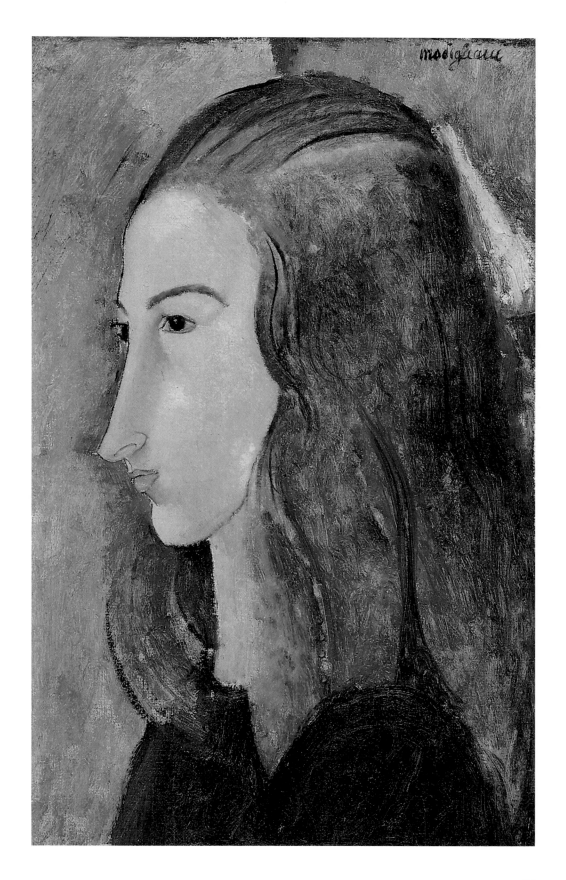

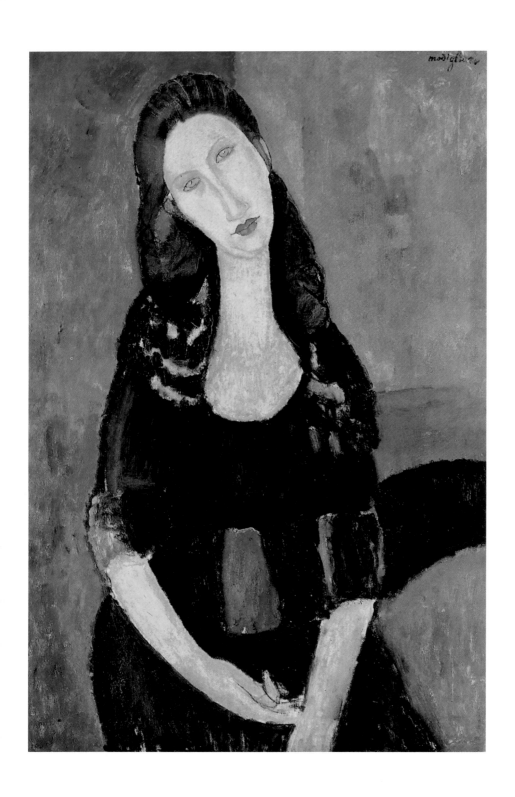

Jeanne Hébuterne, c. 1918

Facing page: *Jeanne Hébuterne*, 1918, detail

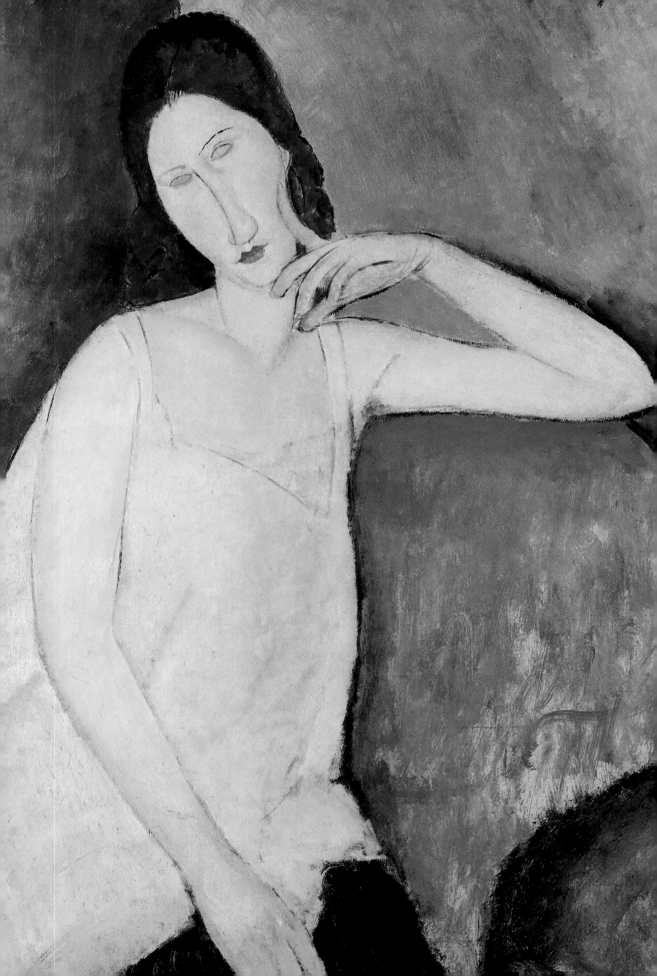

Modigliani's late portraits, however, the subject is not depicted as an individual but as a type.

The same applies to most of the portraits he painted of his companion Jeanne Hébuterne, a French girl whom he met in 1917 at the Académie Colarossi, where both attended life drawing classes. Jeanne was only nineteen at the time, Modigliani over thirty, so the imbalance of their relationship is quite understandable. The young woman, who looked up to him with profound admiration, could never have been an intellectual sparring partner like Beatrice Hastings. Thus the portraits that originated during their liaison always betray the same interpretative approach, which did not derive solely from Modigliani's late style. Just as she resembles a little girl in a series of head-and-shoulder portraits of 1918, so other portrayals invariably depict her as a frail and dreamy child-woman (p. 69). But the realities of communal life – the couple moved in together soon after they met – called for qualities quite other than childish naivety. For her part, Jeanne Hébuterne displayed a constancy and perseverance to which Modigliani was unaccustomed, and which prompted him to rethink his way of life – one in which he had subsisted more on drink and drugs than on nourishing food. The daily discrepancy between romantic liaison and dreary financial worries was intensified when, only a few months after the start of their affair, Jeanne became pregnant.

For Modigliani the imminent arrival of a child bespoke a drastic change. His past life seemed to preclude the likelihood that he would make a responsible parent. Surprisingly enough, however, he took a profound interest in the expectant mother and documented her condition accordingly (p. 70). He depicted the pregnant young woman with great sympathy and intimacy, making no attempt to disguise her sluggish, immobile condition. In the above portrait the lower part of her body broadens and a band of alternating colors calls attention to her rounded belly. Modigliani adopted an increasingly cautious approach to his paints and, thus, to his model. As if trying to effect a symbolic union, in the classical sense, between earthly and celestial love, he stylized his mistress into a Madonna-like creature and, at the same time, envisaged her as a personification of Venus. A portrait

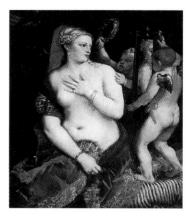

Titian,
Venus with a Mirror, 1555

Facing page:
Jeanne Hébuterne (The Artist's Wife),
1918, detail

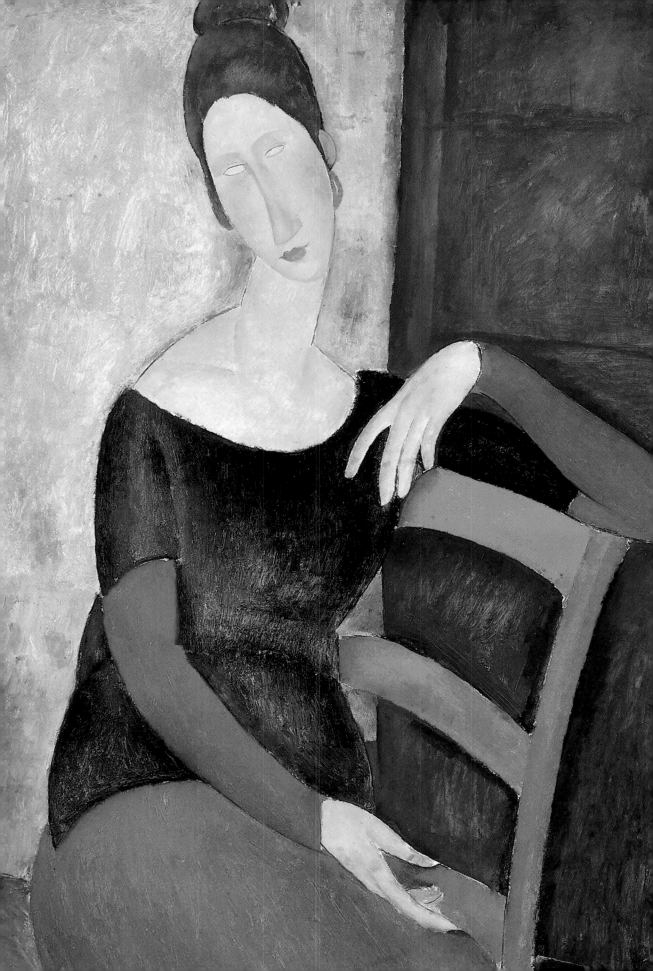

of 1918 is directly modelled on Titian's *Venus with a Mirror* of 1555 but modifies the seated pose and propped hand of the original by means of softly curving S-shaped lines (pp. 72, 73). The paint, which is thinly and evenly applied throughout, refrains from emphasizing any particularly expressive areas such as the hands and face. Instead of concentrating on psychological characterization, Modigliani limited himself to combining structural elements in a decorative manner. A more personal approach is evident in a portrait of 1918 (p. 71). The relaxed pose and dreamily contemplative features are suggestive of an intimate atmosphere. The young woman is wearing a loose, white, sleeveless chemise. Her clothing and the picture's coloration have a lightness that summons up warm, sun-drenched surroundings. Modigliani's recurrent tuberculosis compelled him to spend a longish period in the South of France. He went off with Jeanne to the Côte d'Azur in 1918 and remained there, with interruptions, until May 1919. His palette became brighter and lighter during those months in the south. There, in the peace and seclusion of an atmosphere profoundly agreeable to him, he also extended his range of subjects. His intimate portrayals of Jeanne bear witness to the relaxation of his hitherto austere style.

Young Girl, 1919

The Simple Life – Sentiment and Subject

Modigliani's new, decorative style, with its elongated necks and almond-shaped eyes, gradually brought him success. Few had shown an interest in his analytical, Cubist-influenced portraits with their strong psychological characterization. Now, at a time when movements such as Néo-Réalisme were coming into being, there was a growing demand for representations of the intact human form. Paul Guillaume, the dealer who had released Modigliani to Leopold Zborowski, renewed his interest in the painter and organized an exhibition for him in December 1918. Modigliani, too, seemed willing to make artistic compromises for the first time. Now that he was tied to Jeanne Hébuterne and their daughter, who was born in November 1918, his work became more appealing and saleable.

This inaugurated the phase in which individuals were superseded by anonymous models. Although Modigliani had produced paintings of unnamed persons since his earliest days in Paris, they were experiments in style or composition undertaken for purposes of study alone.

He had also painted the same people more than once – dressed identically, but in different poses. These were not different versions of the same portrait, however; each work brought to the fore different aspects of the same person. This category includes a series of Paul Alexandre portraits, the two versions of *The Cellist*, and the portraits of Beatrice Hastings and Jeanne Hébuterne. In some cases the works were separated in time by only hours or days, in others by many months.

Modigliani's portraits of anonymous models as types include a group devoted to peasant boys painted during his stay in the south of France. As one can infer from their accessories, which are indicative of their social environment, these adolescents were members of the rural population (pp. 76, 77). Their fresh complexions and well-nourished bodies bespeak a life in the open air, and their neat, simple clothing – one of them wears a hat – is the

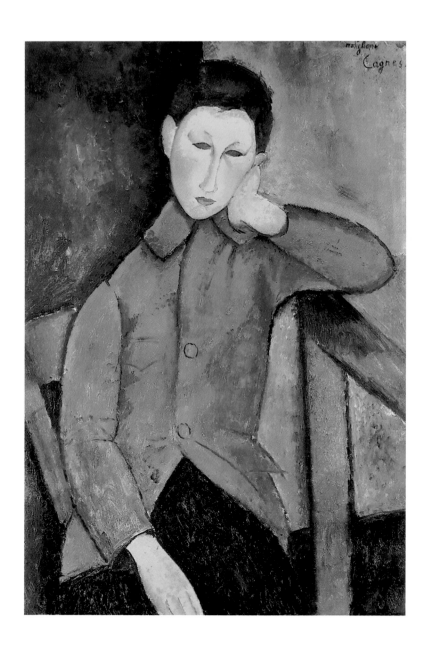

Youth in a Blue Jacket, c. 1918

Facing page: *The Little Peasant,* c. 1918

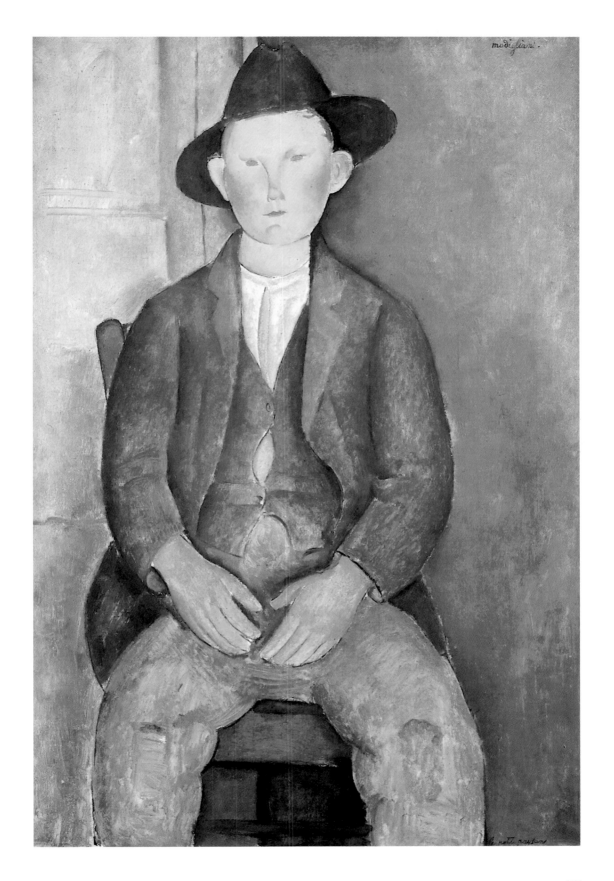

Sunday best they have donned for the occasion. Their surroundings include homely furniture such as chairs and tables. Modigliani keeps their expressions uncomplicated, almost naive. The boy propping his head on his hand makes a more touching than contemplative impression.

The same may be said of Modigliani's other paintings of children and simple folk. We sense that, like the peasant boys, the models are distinguished by being depicted on panel paintings, a special circumstance and honour of which they seem aware.

For all the cool objectivity with which he painted them, Modigliani strove to achieve an emotional proximity to his model and to portray them in an almost sentimental manner. His view of them retained its immediacy and lack of detachment. Even when he put some distance between himself and a figure in order

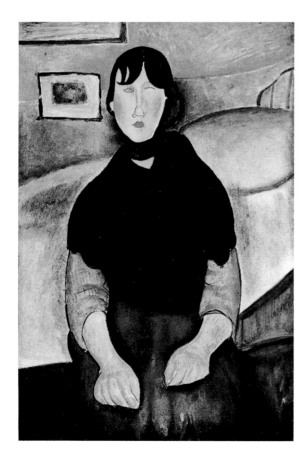

*Jeune femme assise
(La fille du peuple),*
1918

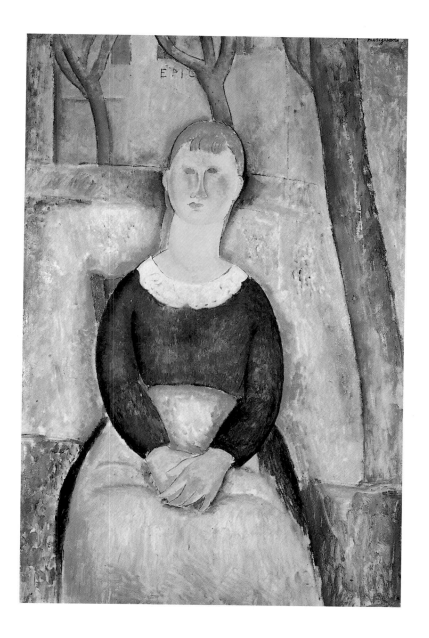

La belle épicière, 1918

to depict more of it, he seldom if ever resorted to a full-length portrait.

With his stylistic repertoire as a basis, Modigliani began experimenting in a new area, using his portraits to tell little stories. His subjects' social status and everyday environment are now clearly discernible. In *Jeune femme assise (La fille du peuple)* we are once again confronted with the usual, frontal view of the

model (p. 78). Dressed in skirt and blouse, she wears the dark shawl obligatory in Mediterranean countries around her shoulders and has rested her coarse, work-roughened hands on her lap. The room in which she is situated – perhaps the only one available to her – is identified as her living and sleeping quarters by the bed and the small pictures in simple frames that adorn the wall behind her.

La belle épicière is seated in front of a wall in a courtyard (p. 79). With her hair neatly plaited, she too is depicted like someone posing for a photograph on a special occasion. Her clothing, which includes a pale apron and lace collar, is simple but neat. The walls and houses in the background suggestive of the girl's everyday village environment. The letters EPIC (for *épicière*) identify her as a grocer or grocer's wife.

Seated Woman with Child, painted in 1919, is of special importance in this context (p. 81). The subject was new for Modigliani, and it was undoubtedly prompted by personal experience. It should be added that the birth of a daughter cemented his ties with Jeanne to such an extent that he decided to legitimize their union.

The young mother and her child are arranged, once again, in a simply furnished room. Despite their rustic surroundings, the composition is strongly reminiscent of the stylized depictions of Madonnas by old masters. The mother sits motionless, facing us with her doll-like infant on her lap. As in many works of this period, the dominant feature is the singular rigidity of both figures.

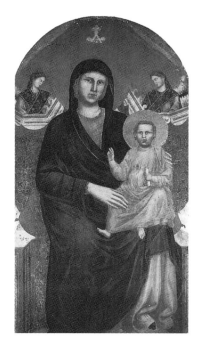

Giotto di Bondone,
Madonna with Child, c. 1300

Facing page:
Seated Woman with Child, 1919

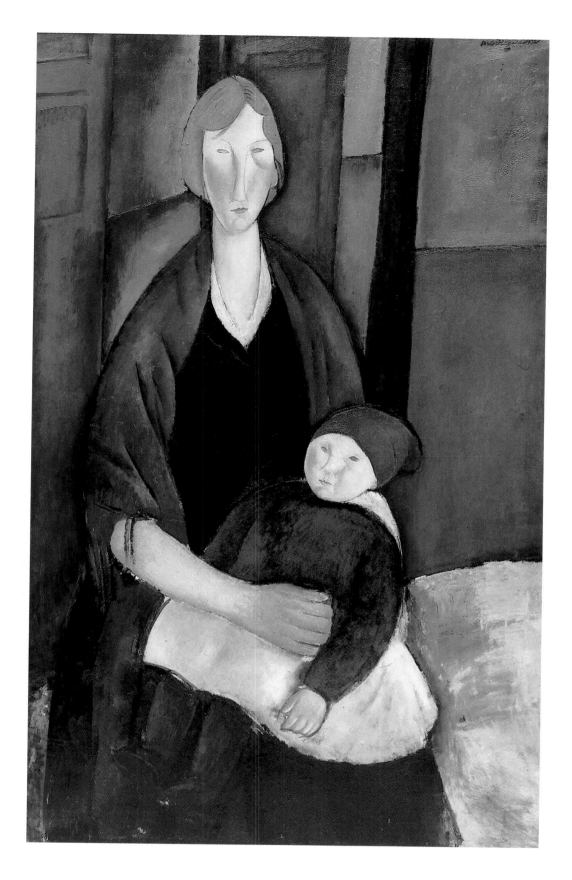

The Perfect Nude

Just as Modigliani's late portraits favored beauty of form over psychological characterization, so all his nudes are concerned with formal problems which are surmounted by painterly means. Logically, therefore, he did not begin to produce his most important nudes until about 1917, when his mature decorative style was applied to that genre.

With respect to the reception of Modigliani's works, his nudes have always been much discussed and acclaimed, yet they amount to little more than ten per cent of his small output of oils. Discounting his studies and caryatids, they number just over thirty. Apart from making a profound impression on the public

Nude with Necklace, 1917

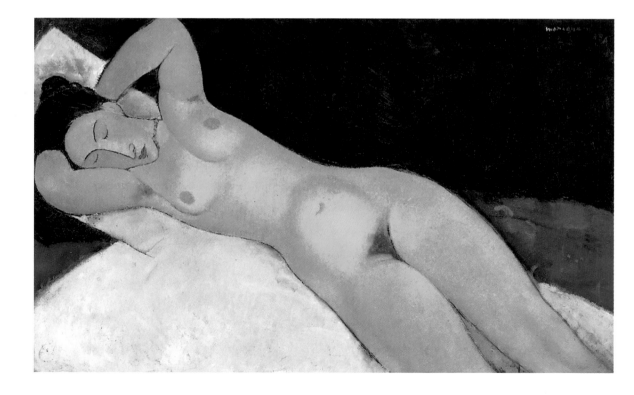

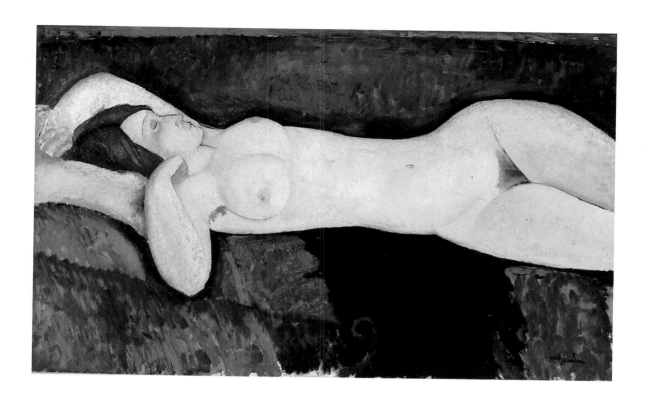

Reclining Nude (Le grand nu), c. 1919

— and the censor — during his lifetime, they also provoked arguments about their pornographic content many years later. Even after the Second World War, New York's Guggenheim Museum was compelled to defend a proposal to have reproductions printed of its *Nude with Necklace*.

Modigliani's nudes have been variously described as fascinatingly sensual and coldly repulsive. The verdicts passed on these works, which have caused such offense, could hardly be more diverse. This is because, unlike comparable works by artists such as Picasso and Matisse, or friends of Modigliani's such as Kees van Dongen and Tsugouharu Fujita, Moise Kisling, and Jules Pascin, his canvases make room for the female form alone. The style is simultaneously naturalistic and idealizing, without making the slightest attempt to disguise his models' stark nakedness, for instance with rough, coarse brushwork.

None of the women depicted by Modigliani possess any individual character traits. They are merely his models, and to

assume that he had an affair with any of them would be purely conjectural. Any stories concerning the artist's amorous exploits must be rejected if they are based solely on his nude paintings.

The stylistic and compositional development of the nude within Modigliani's oeuvre progressed steadily until it attained a pitch of perfection. This is undoubtedly exemplified by *Reclining Nude (Le grand nu)* of 1919 (p. 83). Lost to the world, a naked woman reclines, utterly relaxed, on a couch draped with coverlets, her head pillowed on a cushion. Her expression is serene and her eyes are closed. Possibly asleep, she lies half on her back, half on her side, so that her breasts and pelvis are turned towards us, but her face is visible only in profile. Modigliani has rendered her sexual parts still more conspicuous by cutting the figure short above the knees. The woman's body thus extends beyond the picture plane; framed by the warm red and brown shades of the couch, her flesh takes on a kind of radiance.

In *Le grand nu* the essential features of Modigliani's nude painting appear in a pure, heightened form, for no prior work depicted woman so unequivocally as a symbol of femininity and of her sex in general. Engrossed in her own sensuality, this woman is remote from the viewer; her voluptuous thoughts are centered wholly on herself.

Early Nudes

The road to perfection was a long one. Modigliani had established the poses of his celebrated nudes early on while he was attending life classes at various academies in Paris. It was there that he perfected the treatment of line and his approach to composition, for which his studies at schools in Leghorn, Florence, and Venice had only laid the foundations. While in Italy he had acquainted himself with the art and, in particular, the nude painting of the sixteenth and succeeding centuries. In Paris he supplemented his knowledge of Giorgione and Titian by familiarizing himself with famous nudes by Velázquez, Goya, Ingres, and Manet.

Modigliani's Paris sketchbooks and studies prior to 1914, which did not become accessible until Paul Alexandre's papers were published, reveal how he perfected his skill. One technique he employed was to work towards a finished composition by tracing successful outlines from one sheet on to another. In his nude drawings he was often concerned with only one detail of a figure, always striving, however, to produce a convincing outline. The compositional features of many of the reclining nudes for

Reclining Nude, 1917

which he subsequently won fame were already laid out in ink or crayon during the years preceding his sculptural phase. Their diagonal structure, in particular, was the fruit of earlier studies.

The few nudes Modigliani produced in oils prior to 1914 are modelled stylistically and compositionally on those of contemporaries such as Toulouse-Lautrec and Cézanne.

Nude (Nudo dolente) portrays a woman under great physical and mental strain; seated, her head is flung back with eyes shut and lips slightly parted (p. 87).[9] Her shoulders are hunched, her arms hang limp with her hands resting on her thighs. The paint is applied in a rough, almost scratchy way that heightens the picture's dramatic impact in a manner reminiscent of works by Edvard Munch or Franz von Stuck and other artists of the *fin de siècle*. They aspired to set free and lend a new role to a genre burdened by tradition. Using a boldly aggressive style of portrayal, the nude became symbolic of an art that was liberating itself from strict rules. The Symbolists' endeavors were not enough for the Futurists, whose 1910 manifesto demanded that nudes be prohibited on the grounds that they were a reflection of hidebound bourgeois sentiment.

Modigliani remained relatively untouched by all these trends. Although *Nudo dolente* – the anguished nude – is in the *fin de siècle* tradition, it does not rise above a mere adaptation of Symbolist principles. Nor did any comparable works follow. The only other portrait to convey the same tension is his *Nude* of 1917, which depicts a woman in the spasms of ecstasy (p. 85). Unlike the tormented *Nudo dolente* of 1908, Modigliani's later works were concerned with sexual excitement and tension.

Towards the end of his first phase as a painter, Modigliani's nude studies were influenced by a new idea of form and, thus, governed by the geometricizing process from which his caryatid figures derived. During his subsequent years as a sculptor he completely abandoned sensual portrayals and, until 1914, employed the female figure exclusively as a basic element of form and force. He made numerous drawings as studies for his sculptures, although one of his caryatids of 1911/12 was also executed in oils (p. 89). Modigliani distorted natural anatomy so as to give effect to the formal principles of "primitive" African and Asian

Nude (Nudo dolente), 1908, detail

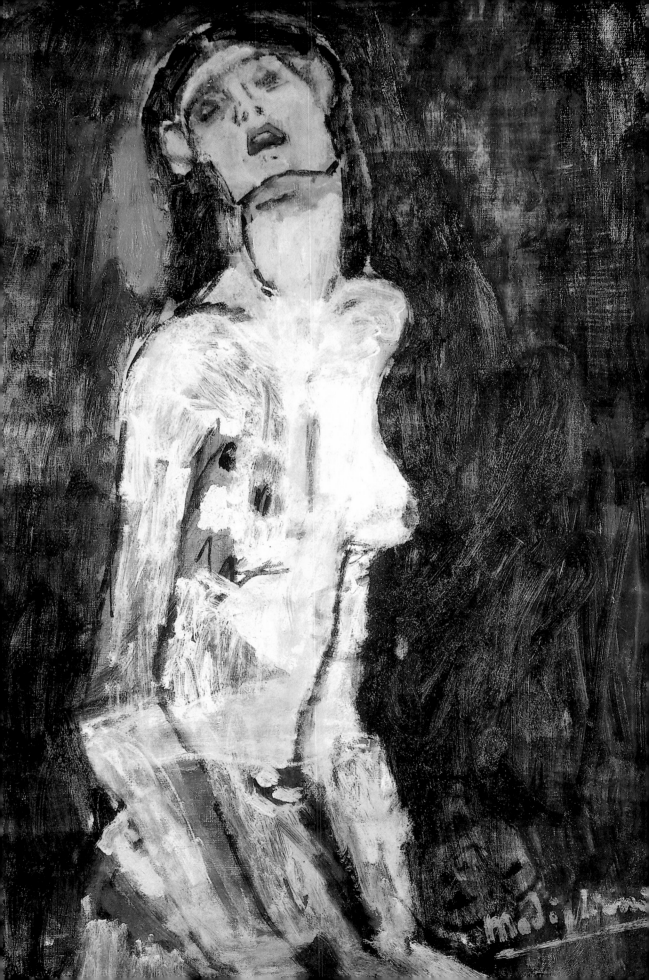

art. He thus deprived the female form of any sensual aura and saw it as an object of countervailing lines of force. Each part of the body becomes a segment of a stereometric figure. The stylized faces alone, whose expressions resemble those of ancient Egyptian or Mycenaean figures, radiate inner serenity and rapture. But Modigliani not only took his direction from the geometricizing principles of "primitive" sculpture; he also made use of stylistic elements from the contemporary art of Constantin Brancusi, his main artistic influence. The caryatid drawings are also suggestive of Picasso's Cubist works of *c.* 1907, the period when *Les Demoiselles d'Avignon* originated.

It was not until the end of his sculptural phase that Modigliani's caryatids — initially upright and only later crouching or kneeling figures — became softer and more animated. They were not reinvested with a sensual aura until 1916 and thereafter.

Caryatid, c. 1913/14, Gouache

Facing page:
Caryatid, 1911/12

Consummation

The *Seated Nude* in London's Courtauld Institute Galleries (p. 91) is one of the first of a series begun at the end of 1916. Whereas most of Modigliani's nudes are in a recumbent position, this one is seated and erect. His view of the figure runs from head to upper thigh, almost entirely filling the canvas, and his palette and brushwork create a very naturalistic and three-dimensional impression of the body with its soft, rounded shapes. The distorted anatomy and geometrical shapes found in his portraits of the same period have been abandoned. Instead we are confronted with Modigliani's endeavor to portray the consummate harmony of the female form. The woman is leaning back, propped on her hands. Her head rests on one shoulder as it does in many of the caryatids, but here the pose creates quite a different effect. The model's closed eyes and faint blush lend her a prim, almost bashful air. All Modigliani's erect nudes display the same reserved and almost naive expression. These women do not exhibit their nakedness in a matter-of-fact manner — indeed, many of them make a symbolic attempt to cover themselves with a chemise or a cloth. The seated or standing position debars us from an entirely sensual approach to the subject. When Modigliani portrays a woman sitting erect who is also looking straight at us, for example *Elvira* (p. 92), he changes the perspective to make her seem small and inconspicuous. This divests the viewer of his voyeur's role. *Elvira*, who remains a depersonalized model despite her name — is not deep in a dream from which we may rouse her, nor does she tempt us with a prim, affected glance. She wards off any erotic fantasies by looking strait at the viewer. This change of mood suggests that Modigliani painted her in the south of France. *Elvira* belongs to the group of portraits devoted to simple folk and youthful rustics. The few nudes that fall within this category depict child-women unaware of their sexual charms.

Red-haired Young Woman in a Chemise, likewise done in colors brightened by the Mediterranean sun, was painted in an

Seated Nude, 1916, detail

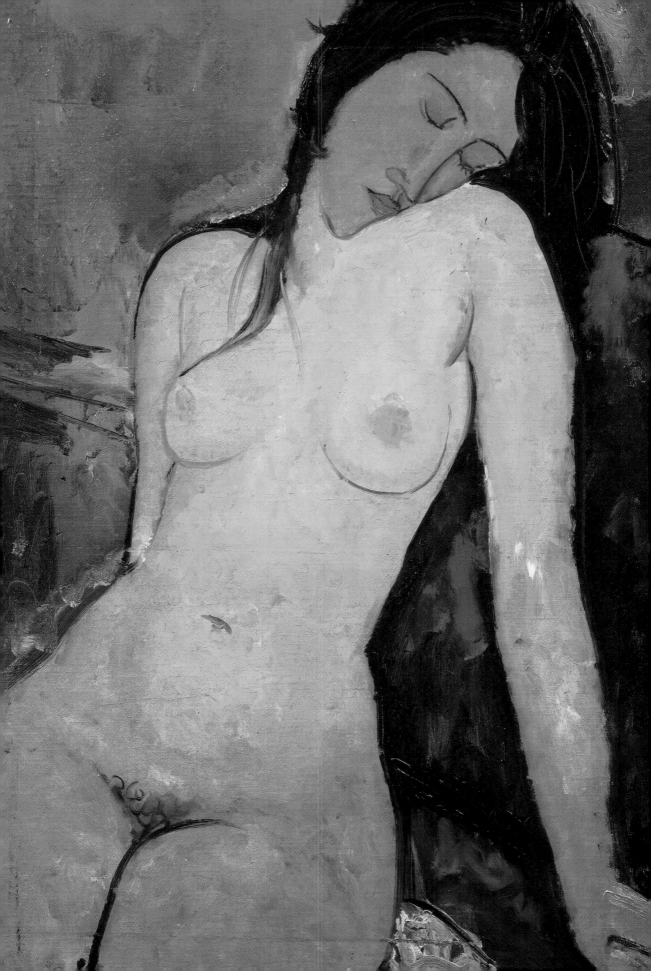

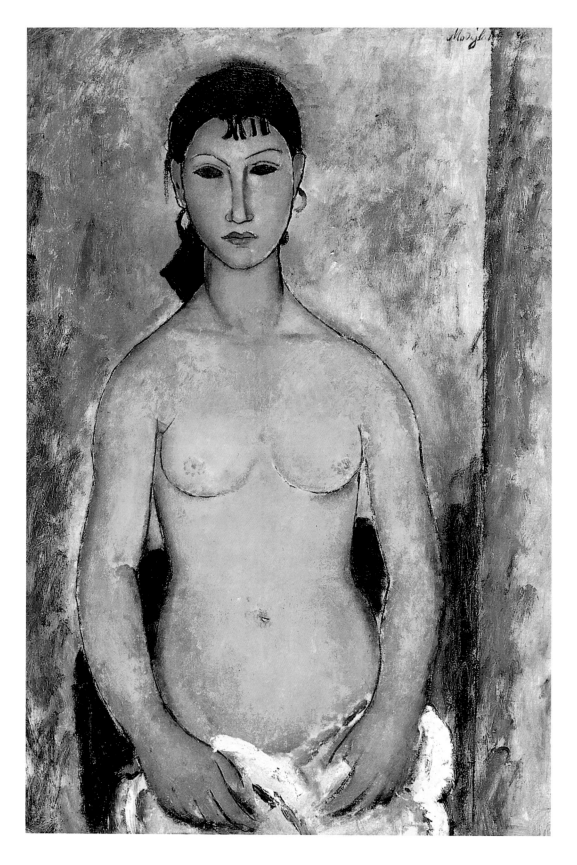

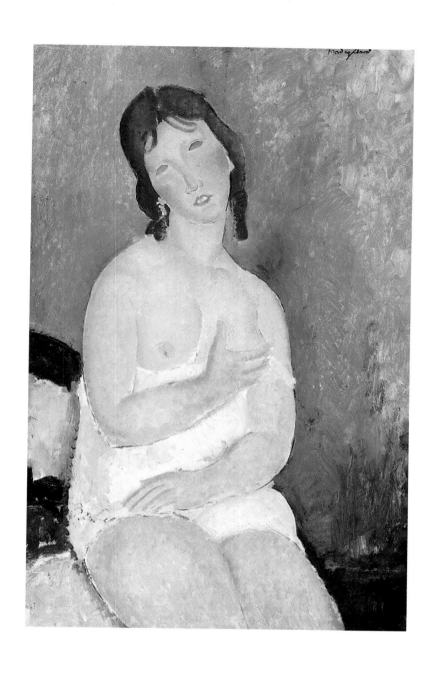

Red haired Young Woman in a Chemise, 1918

Facing page: *Standing Nude (Elvira),* 1918

Seated Nude,
c. 1917, Pencil

extremely ungainly pose (p. 93). The scene suggests that she was
about to remove her chemise when Modigliani asked her to sit
down on the bed or couch. She regards the artist with her head
tilted to one side, but her alluring pose is nullified by a far too
childish expression. One hand cups her bare breast, the other lies
across her lap. If Modigliani was trying to make play with the
traditional elements of the genre and create erotic tension by
concealing the body, he achieved the opposite effect. What pre-
vails in this picture is the sentiment characteristic of his child
portraits, and only a pedophile would find it titillating.

Overt Sexuality

Modigliani's series of "scandalous" nudes was initiated by the one in Washington's National Gallery, which probably originated in 1916 (below). Since he seldom dated his works, their chronological order can only be established by reconstruction, which leaves some room for personal interpretation. This applies in particular to his nudes, some series of which can only be given approximate dates. Several of his formal principles, which are still discernible in the Washington nude, were first developed during his sculptural phase. As in portraits of the same period the structural elements of the face are at odds, whereas the body is realistically depicted and composed of soft, rounded lines. The candour of the portrayal is mitigated by the position of the hand beside

Nude, 1916

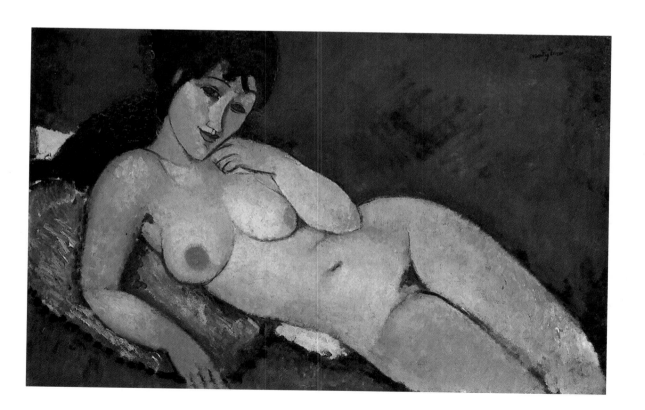

the chin. *Reclining Nude*, also known as *Almaisa*, makes a far more forthright impression (below). The curve of the hip possesses a sensual appeal that reminds one of sketches by Henri Matisse. Depicted almost full-length, *Almaisa* does not create as immediate an impact as her successors. Because the whole of the red couch beneath her is visible, she appears small and remote. Tamed, as it were, she resembles a Playmate or cover girl.

Reclining Nude (Almaisa), 1916, Pencil

Reclining Nude (Almaisa), 1916

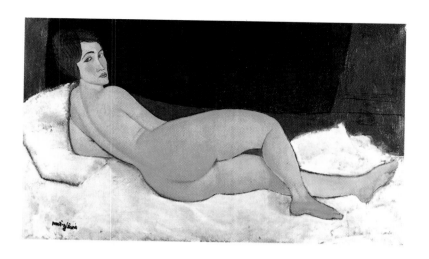

Nude, 1917

Beginning with *Almaisa*, Modigliani launched a more direct and aggressive assault on the viewer. In contrast to his preliminary drawing for the finished work, his subject is awake and active, not asleep (p. 96).

Artists of every period have adapted their predecessors' motifs or copied their compositions. In so doing, they not only adopted their technique but often presented a personal view of the works in question. Modigliani's nudes offered his own interpretations of celebrated works by Giorgione, Titian, Ingres, Velázquez, Goya, and Manet.

One such example, reclining on her left side, is the *Nude* of 1917 (p. 96). Modigliani modelled its composition on Ingres's *La Grande Odalisque* of 1814. In contrast to the earlier work, however, he isolates the naked figure from all ornamental and, thus, distracting accessories. She does not exhibit the same air of relaxation, and her lazy, lascivious gaze acquires a hint of uncertainty, as if she is questioning the appropriateness and significance of her pose. True to his personal style, Modigliani stresses the outline, which encloses the woman's body from head to foot like a second skin and divorces her from her surroundings. Thus isolated, she is merely the artist's object on display.

One of the "scandalous" nudes painted in 1917 resulted in the closure of the only one-man exhibition Modigliani was ever accorded in his lifetime. Jointly organized by Leopold Zborowski

and the gallery owner Berthe Weill, it opened in October 1917. To attract the public they hung one of the nudes in the gallery's display window, which, as ill luck would have it, was situated immediately opposite a police station. As soon as the officer on duty caught sight of the picture and the inquisitive throng surrounding it, he ordered its removal and closed the exhibition. What occasioned this step, apart from outrage at Modigliani's depiction of pubic hair, was primarily the figure's unabashed gaze and undisguised nakedness.

The nude that led to the closure of the exhibition may have been *Reclining Nude*, now at the Staatsgalerie in Stuttgart (below). Diagonally sprawled across the canvas, the woman seems to be positively offering herself to us. The emphasis is entirely on her nakedness. In order to achieve this effect, Modigliani has shortened her body by using a close-up perspective. The head and right upper arm look small and insignificant, the left arm is almost entirely invisible, as are the knees, shins, and feet. The

Reclining Nude, 1917

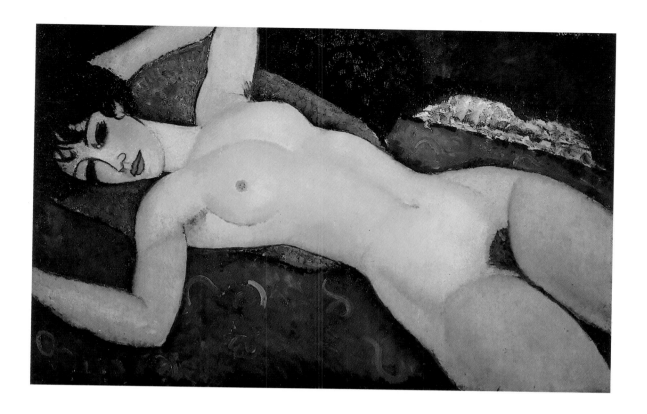

Nude on a Cushion, 1917

warm coloring, which makes a cosy and inviting impression, create an ambiance of emotionally-tinged sensuality. The warm skin tones stand out against the red background, which simultaneously anchors and silhouettes the woman's body. Some welcome rhythmical elements are provided by the white pillow beneath her head.

Modigliani adopted a similar palette in the nude belonging to the Mattioli Collection in Italy (above). Together with the figure's blank eyes, the bluish-green cushion and jet-black hair serve to heighten the picture dramatically. Like the Stuttgart nude, this one has her arms folded behind her head. The placement of the arms and the figure's diagonal arrangement in both works are reminiscent of Francisco de Goya's *Naked Maja* of 1800 (p. 100). Goya's painting, of which a clothed version also exists, caused as much of a sensation in its day as Modigliani's nudes in the twentieth century.

In addition to Goya's *Naked Maja*, Modigliani was acquainted with Edouard Manet's *Olympia* of 1863 and used it in his com-

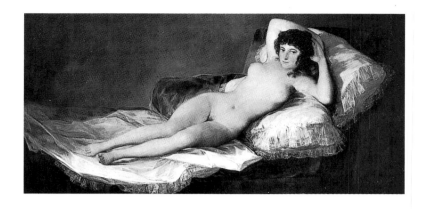

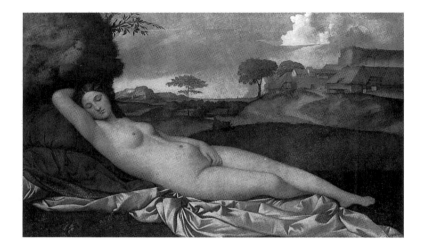

position. He did not, however, adopt Manet's critical and ironic-
al interpretation of Goya, nor did he endow his anonymous
model with the self-assurance that emanates from *Olympia* and
the *Maja*. To him, the only objects of interest were the woman's
body and, more especially, her breasts and pudenda.

In contrast to her very lifelike body, the blank eyes of the
Mattioli nude look dead. This depersonalizes the model so thor-
oughly that her face resembles a mask and her body is reminis-
cent of the female fertility figures that occur in "primitive" sculp-
ture. In this context, Modigliani's figures could also be construed
as cult objects for use in appropriate rituals.

The Venetian painters of the sixteenth century are regarded as adepts in the depiction of ideals of feminine beauty. Works such as Giorgione's *Sleeping Venus* of 1508, preserved at Dresden, have become symbols of physical perfection (p. 100). Modigliani adapted this ideal for his own purposes and created an up-to-date conception of the theme. In *Nude with Necklace* he borrowed Giorgione's motif of the recumbent figure with its eyes closed in sleep and arm behind the head (p. 82). Modigliani's painting radiates harmony and relaxation. Bereft of accessories and landscape, the woman unashamedly displays her beauty to the full. The jewel necklace heightens the model's lavish appearance.

Another of Modigliani's nudes, painted in 1919 and among the last works he devoted to the genre, also depicts a woman, fast asleep, similar to the one in Giorgione's painting (p. 100). Her head likewise rests on one arm; the other is hidden behind her body. In this work Modigliani applied the paint in a thin glaze and varied his palette by embedding the pale flesh tint in brownish shades.[10]

Nude, 1919

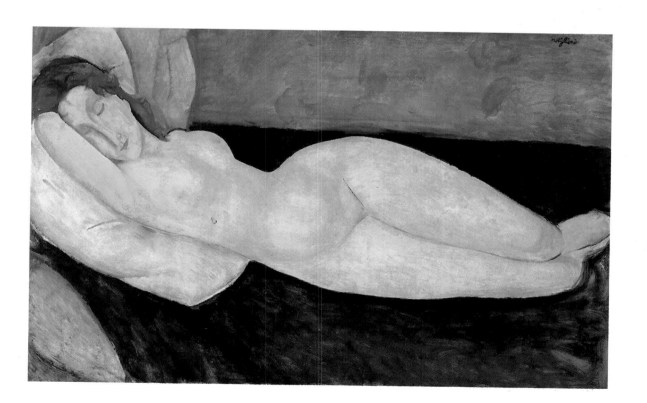

Le grand nu, produced in 1919, represents the culmination of the last series of reclining nudes, uniting all the qualities that render them so uncommonly expressive. Warmth, relaxation, and voluptuous contentment are harmoniously combined. *Le grand nu* has her eyes closed and her head averted in a way that lends the fullest possible expression to the seclusion of the scene and the inapproachability of her self-contained sexuality – characteristics foreshadowed by his other dreaming nudes.

The exceptional nature of Modigliani's works becomes apparent when we compare them with other, similar nudes of the time. Paintings like Moise Kisling's *Nu sur un divan rose* of 1918 (below) or Tsugouharu Foujita's *Youki, déesse de la neige* of 1924 (opposite) demonstrate that both artists were far more traditional in their approach than Modigliani. Where Kisling rendered his work innocuous with a variety of accessories – a bed, pillows, and a fruit bowl – Foujita blunted the impact of his nude by giving her white skin a surreal appearance. Modigliani did not aspire to launch a pictorial revolution with his nudes. That is why they preclude comparison with works by great avant-gardists like Picasso or Matisse, who employed the nude as an aid to stylistic innovation. More than almost any other artist in his field, Modig-

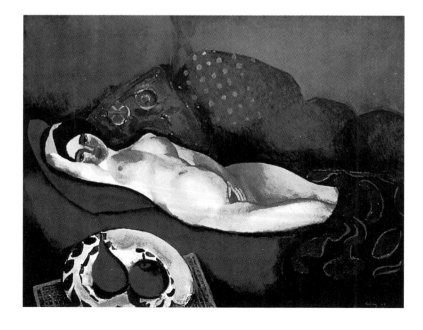

Moise Kisling,
Nu sur un divan rose, 1918

Tsugouharu Foujita,
Youki, déesse de la neige, 1924

liani reverted to the works and traditions of the past, not in order
to break or destroy them, but to adapt them to an art of the
twentieth century. That he was influenced by contemporary
trends can at most be inferred from his sculptures of unclothed
women, which could perhaps be interpreted as a reaction to the
Futurist ban on nude painting. It is nevertheless improbable that
he addressed such theoretical considerations. Much as he may
have admired his predecessors and contemporaries, he always
found a unique approach to his subject. It seems quite under-
standable then that his high regard for the works of Auguste Re-
noir, for example, should have gone hand in hand with an abhor-
rence of this painter's views on nude painting.[11]

Modigliani never intended his nudes to depict a particular
person; he was interested solely in a particular body. Even when
he named them, their names identify the model without impart-
ing any of the psychological characterization he put into his por-
traits. His nude paintings are devoid of the quality that consti-
tutes the charm of so many of his portraits: the unprejudiced and
sometimes caricaturistic acuity with which he laid the personality
bare. Modigliani's nudes were meant as a tribute to the perfection
of the female form. This he celebrated as a symbol of intrinsic

femininity, placing his models' sex in the forefront of his pic-
tures. Modern as his forthright and provocative treatment may
seem, his point of departure and intention were not so. At a time
when artists were seeking a reunion with nature, when the Ex-
pressionists and Fauves were painting their nudes in the great
outdoors, Modigliani created his own very personal version of
this long-desired harmony with nature in the privacy of a bou-
doir.

Seated Nude, c. 1917

The Artist Sees Himself

As his correspondence with Zborowski demonstrates, the mannered style of Modigliani's late works brought him his first financial success. Although the letters also make it clear that he was unreliable when it came to delivering his agreed quota of paintings, his familial obligations were such that he appreciated a regular source of income. He had no wish to settle permanently in the south of France. Deprived of the daily debates on art to which he was accustomed in Paris, he may perhaps have felt too placid in his harmonious rural surroundings. Only in the capital could he truly gauge whether his new style was holding its own against other trends. After two longish stays in the south he returned to Paris for good in May 1919. There remained little time, however, for him to discuss his work with fellow artists. Aged only thirty-five, he died in January of the following year as a consequence of tuberculosis, from which he had never recovered.

Modigliani's recorded comments on his own work are scanty and not particularly illuminating. As best we know, he liked to style himself to friends and strangers as a foreigner and Jewish outsider. To judge by the remarks he made about the artist's role while studying in Italy, he continued to regard himself a *superuomo* and member of a social élite. Few of his paintings display biographical associations. Of those that do, *Bride and Groom* can be related to his affair with Beatrice Hastings just as *Seated Woman with Child* is a reflection of his own paternity.

For all his interest in people and their personalities, Modigliani drew the line at self-representation. His oeuvre contains only one *Self-portrait*, painted in 1919 (p. 108), though an earlier picture, a *Pierrot* of 1915, is often taken to be a self-portrait in a symbolic sense (p. 107). The latter, which can be seen as mirror of the artist's soul, displays features characteristic of Modigliani's post-sculptural phase.

In *Pierrot*, as in the portraits of Diego Rivera and Frank Burty Haviland, the paint is dabbed on in a pointillistic manner, es-

pecially in and around the face. Stylistically the work approximates the red-and-green head study of 1915, in which volume is imparted to the face by applying the complementary color red to a green ground. In addition, *Pierrot* exhibits geometrical, angular forms. The figure's pose conveys a mixture of reticence and contemplation. The right eye gazes into infinity; the left is inward-looking and blind to the beholder.

Pierrot bears no outward resemblance to the artist. We can infer that this work is a self-portrait from the inscription "Pierrot" at the foot of the painting. Modigliani was familiar with the tradition of self-portraits in the guise of pierrots, clowns, or circus artistes. Numerous drawings testify that the theater and music hall were themes to which he had devoted himself in the past, especially during his early years in Paris. He was also acquainted with Picasso's portrayals of entertainers and acrobats. Against this background and by analogy with his own self-image, we can infer that he may have identified with such a figure. It is possible that he liked to see himself as someone who amused and entertained others, but whose true personality remained hidden.

In contrast to the melancholy-looking *Pierrot*, a work which seemed to launch and establish Modigliani's second career as a painter, the *Self-portrait* of 1919 could be interpreted as his farewell to an artistic existence. Although he depicted himself as a painter with brush and palette at work in front of his easel, the backwards-tilted head and the blank, narrowed eyes convey no more than a theatrical pose expressive of self-pity. The figure symbolizes an artistic nature inwardly torn and scarred by its battles with art. The smooth chromatic and formal execution and the implausible, excessively dramatic staging of Modigliani as an artist at work are unconvincing. As evidence of self-portraiture, the picture is little more substantial than its paint, which was applied in a thin glaze.

Pierrot, 1915, detail

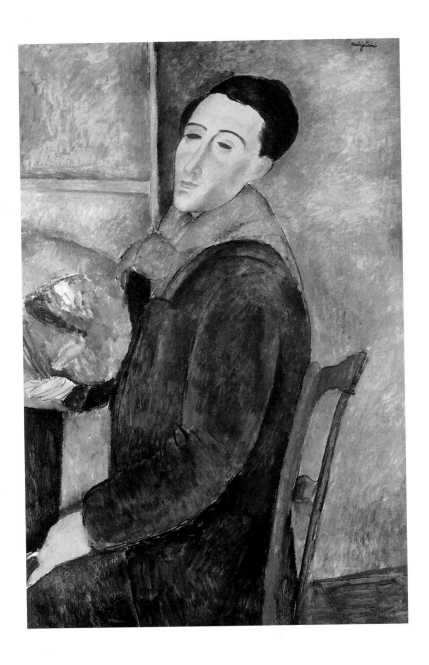

Self-portrait, 1919

Conclusion

Modigliani died in January 1920. Soon afterwards his works began to increase in value, not least because of an exhibition held at the Galeries Montaigne in the year of his death. Some clever dealers were able to increase their profits by adorning authentic works with signatures in the painter's style. It was not long before new "Modiglianis" appeared on the market, likewise commanding high prices. Since then the task of authentication has become increasingly difficult. According to current estimates there are some four hundred original paintings and twenty-five sculptures in existence. The number of drawings cannot be precisely determined. The most recent debate about the authenticity of Modigliani's works was triggered a few years ago by the publication of several hundred works on paper belonging to the Paul Alexandre collection. Prior to this, in 1984, a group of students had caused a flutter among journalists and experts. The youngsters, who claimed to have recovered a series of sandstone sculptures from the city moat at Leghorn, maintained that Modigliani had thrown these works into the river in a fit of anger during his last stay there. Experts were divided over their authenticity, but they debated the matter long and seriously enough to be laughed to scorn by the students, who publicly announced that they themselves had carved the "Modiglianis" to mark the hundredth anniversary of the artist's birth.

Comparative examination provides the answer to the question of authenticity. Detailed study of originals is the best source of information about an artist's working methods, his signature and brushwork, his choice of colors, compositional predilections, and many other things. Further information about techniques and materials can be obtained with the aid of X-rays and infrared light. The Paris retrospective of 1981 achieved important results in this field and developed guidelines for authenticating the artist's signatures and methods of procedure.[12] The flawless provenance of a work is a second important method. It is hardly

necessary to question the authenticity of *Jacques and Bertha Lipchitz*, whose origins were documented by Lipchitz himself, considering that private collectors of the caliber of Frederic Clay and Helen Birch Bartlett acquired it from a reliable source in the early 1920s and passed it on direct to the Art Institute in Chicago.[13]

Public collections have always been wary of Modigliani's works. One rare and early exception was Grenoble Museum, which acquired *Lunia Czechowska* in 1923. Most of the works now in public ownership have found their way into museums by way of foundations and bequests from private collectors like Jean Walter and Paul Guillaume or Geneviève and Jean Masurel.

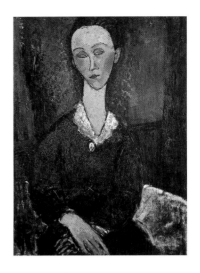

Lunia Czechowska, 1917

The role adopted by Modigliani as a portraitist and painter of nudes scandalizing the public in the early 1900s is a dichotomous one. With his deep-rooted mimetic ideal and his firm attachment to the anthropomorphic depiction of the human form, he could well have been a nineteenth-century salon painter. Because of his close contact with modernist movements in Paris, however, he was exposed to the debate on pictorial autonomy, and his solution to this conflict is expressed in a highly individual form of painting.

Modigliani's art can be viewed in relation to movements that achieved a breakthrough in the 1920s – verism and Ingrism, for instance – or even to Picasso's classicism. Similarities can also be discerned between his treatment of line and drawings of Kahnweiler and his wife made by Juan Gris in 1921. But Modigliani's painting, whose style underwent a consistent and stringent process of development, cannot, as we have already pointed out, be viewed from a comparable programmatic viewpoint. His art was the point of impact between his conservative, middle-class origins and the world whose social and political framework had finally disintegrated. He strove to do justice to the modern age by stressing the autonomy of pictorial resources and, at the same time, yielded to bourgeois sentiment in his character portraits. Neither the precursor nor the pioneer of a new movement, he remained a loner and a stylistic outsider, and his extraordinary nudes are particularly illustrative of his singular role.

Modigliani did not aspire to create a new vision of the world or employ his art to make it a better place, nor did he devise a

new conception of life. The inherent conflict between traditionalism and modernity was a problem common to Italian artists in particular. Giorgio de Chirico, for example, was likewise confronted by the need to break with an overly powerful national tradition. By essaying a compromise, Modigliani made an outstanding and highly individual contribution to the art of the twentieth century. Had he spent his life in Italy, he might have become a popular and prosperous salon painter. The move to Paris enabled him, by treading the narrow path between a new sense of style and traditional ideas of painting, to make a last great contribution to the portrayal of the organically intact human form. Whether as a portraitist or a painter of nudes, Modigliani celebrated the world's human inhabitants in a manner unparalleled in the history of art.

Juan Gris, *Lucie Kahnweiler* and *Dany-Henry Kahnweiler*, 1921

24 bis TOUT PARIS
Rue Laffitte
(IX°)
1908

Short Biography

Self-portrait, 1899

›Dedo‹ with his nanny, c. 1886

Leghorn 12 July 1884

Born the fourth and youngest child of Flaminio Modigliani, banker, and his wife Eugenia Garsin.

1897

First drawing lessons.

1898

Enrolls in Guglielmo Micheli's class at Leghorn's school of art. Studies landscape, portraiture, still life, and the nude.

1901/2

Tours central and southern Italy.

Florence May 1902

Enrolls in Giovanni Fatori's class at the Scuola Libera di Nudo. Visits old master galleries and the quarries at Carrara and Pietrasanta. Resolves to become a sculptor.

Venice March 1903

Admitted to the Reale Istituto di Belle Arti. Becomes acquainted with the budding Futurists Umberto Boccioni and Ardengo Soffici.

Paris Winter 1906

Moves to Paris. Acquires studio in Montmartre and attends the Académie Colarossi. Produces works in the style of Henri de Toulouse-Lautrec and Paul Cézanne.

1907

Meets Dr. Paul Alexandre. Joins the Société des Artistes Indépendents. Exhibits at the Salon d'Automne and at the studio of the sculptor Amadeo de Souza Cardoso.

Modigliani with his school-friends
(front row, 3rd from right)

Modigliani (left) with Pablo Picasso and André Salmon, c. 1914

Modigliani in Montparnasse, c. 1915

1908

Shows six works at the Salon des Indépendents.

1909

Meets Constantin Brancusi and starts work as a sculptor. Moves to Montparnasse. Visits Leghorn.

1910

Shows six works at the Salon des Indépendents.

1911

Exhibition at the studio of Amadeo de Souza Cardoso.

1912

Exhibition of sculpted heads at the Salon d'Automne.

1913

Visits Leghorn and Carrara for the last time.

1914

Represented in the "Twentieth Century Art" exhibition at the Whitechapel Art Gallery, London.

1914/15

Gives up sculpture and resumes painting in the divisionist-pointillist style. Meets the British writer Beatrice Hastings. Signs contract with the art dealer Paul Guillaume.

1916

Switches to the art dealer Leopold Zborowski. Produces character portraits using geometric shapes in a Cubist manner.

1917

Resumes nude painting. His portraits begin to exhibit elongated faces and almond-shaped eyes. Sets up house with the art student Jeanne Hébuterne. Short-lived exhibition at the Galerie Berthe Weill, the only one-man show to be held in his lifetime.

Nice/Cagnes 1918

Recuperates from his tuberculosis in the south of France. Produces genre portraits and a few landscapes. Birth of a daughter on 29 November. Paul Guillaume organizes another exhibition of his works in Paris.

Modigliani with his
friends, including
Moise Kisling
(3rd from right) and
Pablo Picasso (right),
in Montparnasse

Modigliani in his
artist's studio, c. 1919

Jeanne
Hébuterne,
dressed as
a Russian,
1917

Paris May 1919

Returns to Paris for the last time, accompanied by Jeanne
Hébuterne and their baby daughter. Represented in vari-
ous exhibitions in London, at the Salon d'Automne, and
elsewhere.

24 January 1920

Admitted to the Hôpital de la Charité, Modigliani dies at
the age of thirty-five. Jeanne Hébuterne commits suicide
the following day.

Endnotes

1 Entry in his mother's diary dated 10 April 1899, quoted by Jeanne Modigliani in *Modigliani senza leggenda*, Florence 1958, p. 27.

2 Quoted by Giovanni Scheiwiller in *Amedeo Modigliani, Selbstzeugnisse, Gedichte*, Zurich 1958, pp. 33 - 35. Quoted in English by June Rose in *Modigliani: The Pure Bohemian*, New York, 1991, pp. 35.

3 Quoted by G. Scheiwiller (note 2), p. 37. Basil Hallward's avowals in Wilde's novel tend, however, to express the contrary of Nietzsche's ideas. Quoted in English by J. Rose (note 2), p. 36.

4 Modigliani was too poor to afford professional models. This circumstance enabled him to develop a personal approach to his subjects.

5 The use of inscriptions for other purposes, such as the identification of his subjects' social status, are not discernible in his works until 1918 and thereafter.

6 *"C'est Modigliani qui m'a donné confiance en moi."* Quoted in *Omaggio a Modigliani (1884 - 1920)*, published on the tenth anniversary of the artist's death, Milan (S.A.T.E.), 25 January 1930, unpaginated.

7 Although comparison with the genre-like portraits of peasant boys painted in 1918/19 reveals how much more of the sitter's personality and character are conveyed in the Kisling portraits.

8 The placing of the hand before the breast – a gesture of humility – is an allusion to Italian masterpieces such as the Madonnas by Parmigianino.

9 Modigliani painted this work over another, presumably for want of a new canvas. Visible in the bottom right corner is the head of a red-haired young woman, but whether it was by Modigliani or some other artist is uncertain.

10 Presumably Modigliani found buyers for this work, because there are three almost identical versions of it. In each one he varied his application of paint, and one of them could almost pass for a water color.

11 See E. Brummer, "Modigliani bei Renoir" in Giovanni Scheiwiller's *Amedeo Modigliani, Selbstzeugnisse, Gedichte*, Zurich 1958, pp. 68 - 69.

12 See *Amedeo Modigliani, 1884 - 1920*, exhibition catalogue, Musée d'Art Moderne de la Ville de Paris, Paris 1981, pp. 19 - 47.

13 See Lipchitz's remarks in *Amedeo Modigliani (1884 - 1920)*, introduction by Jacques Lipchitz, Munich/Vienna/Basle 1954, unpaginated.

Selected Bibliography

Ceroni, Ambrogio. *Tout l'œuvre peint de Modigliani*. With a text by Françoise Cachin. Paris 1972.

Cologne, Ludwig Museum. *Der unbekannte Modigliani. Die Sammlung Doktor Paul Alexandre*. Exhibition Catalogue. Cologne 1994.

Kruszynski, Anette. "Das Bildnis Max Jacobs von Amedeo Modigliani." *Pantheon* XLIX, 1991, pp. 186 - 92.

Lanthemann, Joseph. *Modigliani 1884 - 1920, Catalogue raisonné, sa vie, son œuvre complet, son art*. Barcelona 1970.

London, Tate Gallery. *Modigliani*. Exhibition Catalogue. Text by John Russell. Exhibition organized by the Arts Council of Great Britain. Edinburgh/London 1963.

Maiolino, Enzo (ed.). *Modigliani vivo. Testimonianze inedite e rare*. Turin 1981.

Mann, Carol. *Modigliani*. London 1980.

Modigliani, Jeanne. *Modigliani senza leggenda*. Florence 1958, Paris 1961. Published in English as *Modigliani: Man and Myth*. New York, 1958.

Paris, Musée d'Art Moderne de la Ville de Paris. *Amedeo Modigliani, 1884 - 1920*. Exhibition Catalogue. Paris 1981.

Patani, Osvaldo. *Amedeo Modigliani. Catalogo generale. Dipinti*. Milan 1991.

Parisot, Christian. *Modigliani. Catalogue raisonné. Peintures, Dessins, Aquarelles*. Edited by Giorgio and Guido Guastalla. Vol. I. Leghorn 1990. Vol. II. Leghorn 1991.

Salmon, André. *Amedeo Modigliani – Sein Leben und Schaffen, seine Briefe und Gedichte*. Postscript by Jeanne Modigliani. Zurich 1960.

Scheiwiller, Giovanni (ed.). *Amedeo Modigliani – Selbstzeugnisse, Photos, Zeichnungen*. Zurich 1958.

Schmalenbach, Werner. *Amedeo Modigliani. Paintings – Sculptures – Drawings*. Kunstsammlung Nordrhein-Westfalen Düsseldorf/Kunsthaus Zurich 1991.

Verona, Palazzo Forti. *Modigliani a Montparnasse, 1909 - 1920*. Milan/Rome 1988.

Werner, Alfred. *Modigliani the Sculptor*. New York 1962.

Werner, Alfred. *Amedeo Modigliani*. New York 1967.

List of Illustrations